The Photographer's Guide
Senior High School Portraiture

Everything You Need
to Know for Your
Photography Business

Sal Cincotta

 Peachpit Press

The Photographer's MBA, Senior High School Portraiture:
Everything You Need to Know to Run a Successful Business
Sal Cincotta

Peachpit Press
www.peachpit.com

To report errors, please send a note to errata@peachpit.com
Peachpit Press is a division of Pearson Education

Editor: Ted Waitt
Production Editor: Rebecca Winter
Interior Design: Claudia Smelser
Compositor: Danielle Foster
Indexer: James Minkin
Proofreader: Liz Welch
Cover Design: Aren Straiger
Cover Images: Sal Cincotta

ISBN-13: 978-0-321-94012-4
ISBN-10: 0-321-94012-1

9 8 7 6 5 4 3 2 1

Printed and bound in the United States of America

I want to dedicate this to everyone who has been part of making this journey possible and has believed in the vision. I would especially like to thank my wife Taylor for pushing me to give back to education, my mother Terri for always believing anything is possible, and my teammates Laurin, Alissa, and Jenny—who work endless hours making me look good.

Table of Contents

four Post-Production: Where It All Comes Together

five The Ambassador Program

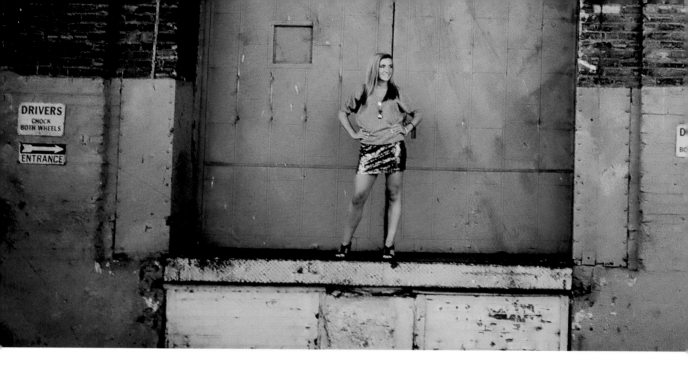

eight Web and Social

nine The Sales Process

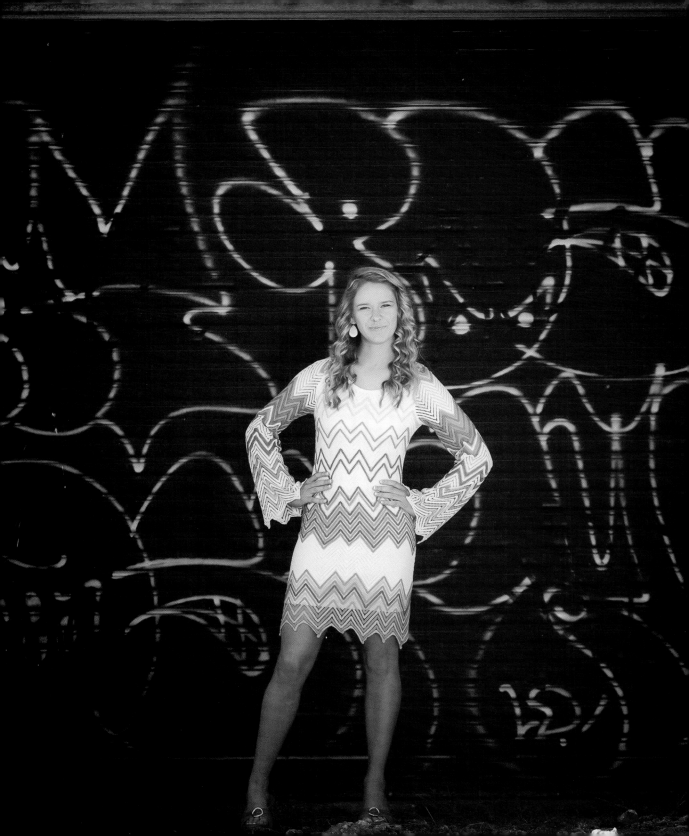

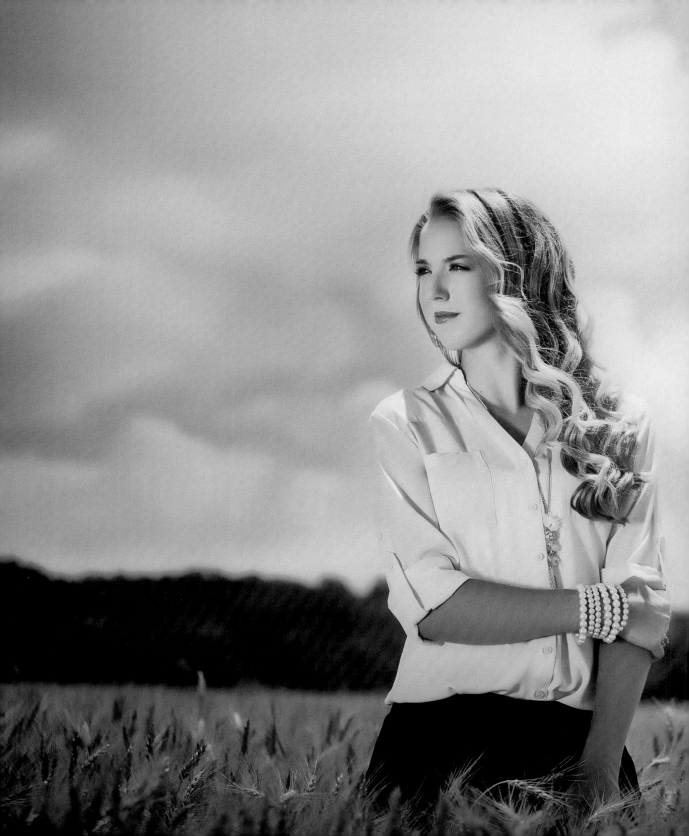

The Senior Market Defined

DEPENDING ON WHERE you're located in the country, the thought of "seniors" will typically evoke a conversation about senior citizens. I assure you, this market has nothing to do with senior citizens. Instead, it should be focused on high school seniors. It's a new and exciting market for some of you, and it's a surefire way to inject new life into your studio.

The first time I mentioned shooting seniors to my mom, she asked, "So, is this what seniors are doing now?" I replied, "Yes, it's a huge market, and every year we have a new crop of them waiting to get their portraits taken. It's a transitional period in their lives." To that she said, "So, when should I get mine done?" And to that, I simply smiled.

What Kids Want

The senior market isn't something new at all. In fact, in a large part of the United States, tens of thousands of high school seniors look forward to getting their photos taken every year. For most, it's a rite of passage.

The biggest challenge for most of you will be to understand what kids want today. As we get older, we all love to think we are hip and cool, but the truth is, most of us are legends in our own minds. Sorry to be the bearer of bad news, but it's true. Not to say we can't have a sense of cool about us; we just have to work a little harder to do it.

Let's take a step back for a second and start with a simple question: What do the kids want? I mean, we know that every year since birth they've had to take the obligatory yearly picture and, since entering the school system, the required school photo. And every year, the kids hate the way they look or are embarrassed by the pictures that come home in the prepaid folder. You know, the ones with bed head, goofy braces, and outdated wardrobes, among other mishaps.

What are the typical complaints? "My pictures look like everyone else's." "I look funny." "That's not how I dress." Or from the parents: "They just didn't capture the essence of my child." And on and on and on. Bottom line—they want something more.

Understanding what seniors want today is no easy task. This is something we have learned over time and are continuing to improve on every year. Here's what I do know:

▸ They want to be cool.

▸ They want to be different from anyone else.

▸ This is a celebration for them.

▸ Did I mention that they want to be cool?

The driving force behind everything we do for our high school seniors is focused on giving them the experience of a lifetime and ensuring their unique style and personality come out in the pictures. If you can accomplish that, you'll run a very successful high school senior studio.

Every kid I know wants to be cool! It doesn't matter what part of the United States—or the world, for that matter—you live in. Kids are kids, and they want to be cool. Granted, fashion-style senior portraits are a Midwest thing. However, it makes no sense to me that it hasn't gained traction on both coasts.

You're telling me that seniors in New York City don't want to be cool but seniors in St. Louis do? Ha! Sorry, I'm drinking coffee while typing this, and I nearly spit it all over my cool MacBook Pro.

The bottom line is that seniors everywhere, and I mean everywhere, want to be cool. Stop convincing yourself they don't want these types of portraits. You're just making excuses. Instead, I'll make the argument that they don't know any better. Think of the opportunity that lies ahead. This is your opportunity to be a leader in your local market. Why wait? Start the trend. Even if there are others offering high-fashion-style portraits, innovate. One-up your competition.

Today's seniors want to look and feel like rock stars and supermodels. Give them what they want.

Stylized Senior Portraits

Most high school seniors are 16 or 17 years old when they take their portraits. It's the last major portrait session they'll have before they get married. More importantly, it's a transitional phase in their lives, where they develop from teen to young man or woman as they prepare to go off to college. This is as big a moment for the parents as it is for the kids.

If we buy into the fact that most teenagers want to be cool and want something that screams individuality as they come into their own, then we should be able to agree that documenting this event in a high-fashion way is a logical progression.

School pictures *suck!* I'm sorry for all of you who do the school picture thing. It's not a slam on you at all. It is what it is. You have three minutes with each student, one backdrop, limited options. Bam! Next! Next! Next! It's an assembly line. Nothing exciting or glamorous about it. This is exactly what the kids hate. They often refer to the photographer as a "creeper" because the truth is, we usually have less than 30 seconds to get the child to loosen up and give us something that remotely resembles a real smile.

I've probably just scared half of you into not wanting to be a photographer of teens. It's not that bad; I promise.

Personally, I love senior portraits. They want to be rock stars and models. They want to look glamorous. They want to look and feel like the celebrities they see on TV. This transcends all cultures and any geographical boundaries. Teens are teens the world over.

If you give them hair and makeup, help with wardrobe, provide cool locations, and offer fashion advice, you'll be well on your way to giving these kids the experience of a lifetime and the sales to power and grow your business.

The Size of the Opportunity

Of course, it's one thing to talk about entering a new market and it's another thing to actually do it. If you're a true businessperson, the first question you should have is, what is the size of the opportunity?

Here's what I want you to think about. You're either starting a new line of business or enhancing an existing one. Either way, the basic questions have to be answered. If you build it, will they come? The short answer is yes.

No matter what you believe, we can surely agree that every year there's a new crop of seniors—the Class of "insert year here." What does that mean to you and your business? Welcome to your first recession-proof line of business. Whoa, what's that you say, Sal? "Recession-proof"? Impossible!

Think about it. Every year, a new crop of high school seniors emerges. Transitioning from clumsy teen to young adult. Getting ready to leave for college. Leaving their friends and family. As I mentioned earlier, these images will more than likely be their last professional portrait session before their wedding. And you think in this society of "only the best for my child" you won't see big sales? Really?

I am only 42 years old, and I'm blown away by the luxuries afforded to today's teen. It really does seem like families are willing to go into debt to send their kids to prep school, private sports camps, singing lessons, dance team, and off-season elite teams, and to buy them new cars, give them a clothing budget for designer clothes, etc. I mean, when I was a teen, it was all I could do to get my family to give me $200 a *year* to buy my entire wardrobe. That's all my family could afford. We were broke. Broke when I was a kid was a whole different kind of broke. It was a broke where your electricity was hours away from being turned off. "Broke" today is a funny kinda thing. Everyone seems to have money for what they want to have money for. A pair of jeans today costs as much as my annual budget for clothing used to be.

Give them something unique, and they will spend! I promise. If they can buy $200 jeans and $150 sneakers, they can afford great senior portraits. Based on that, the opportunity for you and your studio is huge.

Here's what I want you to do. Google your local high school. If you don't know, Google your zip code looking for local high schools. You'll be surprised what you can learn with a little recon.

I Googled my local town, and low and behold, a Wikipedia article came back.

From there, I selected the schools option and that took me to the local high school page on Wikipedia. On the right-hand side, I can see that the high school has enrollment of approximately 2500 students. Divide by 4, and boom—I can deduce that I'm looking at about 600–650 seniors per year! That's just a single school.

Consider that in my local area there are at least 4–5 other high schools I can go after, and you quickly realize this is a monster opportunity. You're looking at roughly 3000 potential seniors looking for their portraits to be taken. Granted, not all are "my clients," but when you consider that a good goal to have is 30–100 sessions per year, depending on how you want to grow your business, you can see I am going after 3 percent of the market. Very achievable.

Are your wheels spinning yet?

The opportunity is a very large one. I would argue that it's *huge!*

We grew our business during the middle of a recession by going after two primary markets—seniors and weddings. Both share a very important trait—there's a new crop every year.

Now maybe you're back to thinking, "Well, Sal, I am in a part of the country that doesn't really go after senior portraits." I want you to look in the mirror

right now and hear and see yourself say this. Repeat after me: "Teenagers in my market are not cool!" Say it again! Now, ask yourself, are you insane? Teens everywhere want to be cool! This is Sociology 101.

Now, if you're buying into this, you are of the right frame of mind to continue on.

Things to Consider

Starting with location, let's take a quick look at some items you'll need to consider next, including the sales process, branding, working in-studio, and the overall client experience.

Location

I know what you're thinking. You live in a part of the world or the country where senior photography isn't a priority. Well, hopefully, you get it: Be a first mover. Go after the market. Create the market! Teach people that they need this kind of photography. If there's no market, look at this as an opportunity to be a leader versus a follower. Can you imagine the market share you have the potential to gain? You'll be able to set the tone. All of a sudden, photographers will be copying you. The other alternative is for you to wait for someone else to read this book and set the tone. Then, you will, in fact, be just another studio. There's a huge opportunity for you to lead here and capture market share.

Now, I am of the mindset that if you offer a superior product it doesn't matter where you set up shop. For example, we're in a small suburb outside of St. Louis. We're not in a huge town; it's a midsized town in blue-collar America.

The key here is to not talk yourself out of it just because of where you're located. Being near a high school is obviously more important than any other factor when it comes to location.

Seniors and their families are less likely to travel longer distances to get their portraits made. I'm not saying it's impossible, but it's less likely than, say, a wedding client. So, keep that in mind when defining your radius.

Sales Process Overview

Another important part of the process is the sales process. Don't mistake the sales process for posting images online or handing over a DVD of images to the client. That is not a sales process. That's just pathetic. Sorry. I know that's harsh, but it's just some real talk. You can't run a real business and just hand this stuff over to your client.

I don't want to delve too deep into the sales process here—we'll discuss that further later in the book. However, it's worth talking about some high-level concepts here before moving on.

If you're going to run a real business, then you need to run it like a business and offer your clients a complete end-to-end solution. Do you really think the average client knows what will look good in their living room? Or have enough artistic vision to know how an image will look in their home, period? What colors match the living room? Should they get a canvas or a large print? How should they frame this image? Hand them over a DVD and these questions will never get answered—not correctly anyway—and worst of all, your sales will suffer.

Be honest: If you're posting these images online today, your sales all but suck! And you're scratching your head, wondering why. It's because you aren't there for your clients. You're letting them make their own decisions. How can that *ever* work out for you or your business? You need to help your clients and guide them through the process.

Start thinking about how you will present to them. Will you do a presentation in-studio or in your home? I'm open to either. In fact, we started from our home. I don't care what you do at this point; I just need you to start thinking about it. We'll explore this further in later chapters. If you're going to continue to do things the same way, then I hope you aren't expecting a different result.

Start thinking about the kind of products you'd like to offer your clients. Again, we'll explore this later, but I want you thinking about it. Will you be high-end, or will you be mass production? This matters when we start thinking about the overall brand. You can't offer high-end products if you're charging $50 on Groupon. It just doesn't work that way.

How quickly will you turn images around for your clients? Again, start thinking about this now. I don't want it to be a shock to you when we go into this later. We show our clients their images in two weeks! Fully edited images. Two weeks! It's a huge competitive advantage for us.

Hopefully I have you thinking about the sales process. We'll explore it and evolve it for you, but things have to change if you're going to find success, and your sales process is going to be front and center.

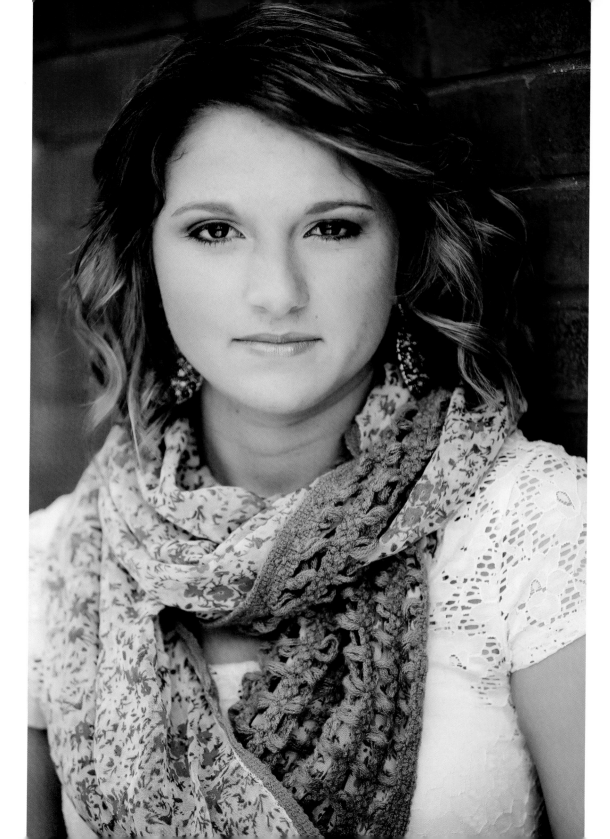

The Importance of Branding

If there's one thing I see photographers all over the world underestimate, it's the importance of branding. I've dedicated an entire chapter of this book to the subject of branding and marketing, but once again, I just want to whet your appetite. What does your brand mean to you? More important, what does your brand mean to your clients?

Everything you do is related to the overall brand. You have to understand this and get it through your head. Now! Not later. Stop procrastinating on this part of your business. It's probably one of the most important facets of your business. If your clients see you as a high-value brand, they'll be willing to pay more money for your services. If they see you as a low-value brand, you're going to attract clients who want the cheapest possible rate for everything. And they're usually more work than they're worth.

Your logo, your packaging, your website, your car, the way you dress—all have an impact on your brand. Yes, the way you dress! Welcome to reality. People are judging you and everything you do within your studio. And all of that leads to assumptions about and decisions based on your brand.

Your brand will truly determine the success or failure of your business. If you think I'm putting too much emphasis on this, then approach it logically. Think about a brand you work with locally. Think about a restaurant you frequent. A good one and a bad one. Let's work with the bad one for now. What made it bad? Was it the service? The product? The way the staff carried themselves or dressed? Was it the presentation of the food? The décor? What about its location? Good part of town, or bad? Hmm...starting to get the picture here?

In the same way that you make decisions based on these factors, your clients are making those same decisions about you and your brand! As for the good restaurant, we'll come back to that because you will be that business! That's why we're here—to make sure you find success for your studio.

Dangers of Working In-Studio

Most "natural light" photographers are scared to death of studio lighting or any lighting other than that of the golden hour. Guess what? Anybody

can be a photographer during the golden hour. You need to understand and learn about light. It can be your friend, but it can also be your worst enemy if you don't know what the hell you're doing with it. We'll dive into lighting situations in a future chapter.

For the moment, I just want to touch on the concept of shoots versus on-location shoots. For a moment, let's assume that you know and understand all lighting scenarios. I consider myself an advanced lighting person using both studio lighting and off-camera flash, along with a multitude of accessories. When it comes to seniors, I want nothing to do with studio sessions. They become extremely limiting from a creative perspective. You may not agree with me, but the bottom line is that when you're working from a studio location, you have finite space and finite backdrops. Kids love diversity. They don't want their pictures looking like everyone else's shots; they want diversity and individuality.

For this very reason, I love shooting on location. There's no limit to what I can accomplish. Now, mind you, this is my personal preference. This is the formula we've used to stand out from the crowd. Everyone around me shoots in the studio because it's easier. No travel, no heat in the summer, no tough lighting scenarios. It's a 100 percent controlled environment. And the result? The same portrait, kid after kid. How can your brand stand out in a market of sameness? It can't!

I want you to consider offering an on-location session and force yourself out of your comfort zone. This will make you a better photographer in the long run, and it will force you to learn about creating great light at any time of day!

Creating Buzz

Want to be a senior photographer? Then you better get good at generating buzz for your brand. Word of mouth is a huge part of your success. The best website and all the marketing in the world will be useless if the kids aren't talking about you and your studio. You need *them* to create buzz. When those kids go to school and start talking about what a good time they had... the buzz will begin. And it will build.

That buzz will become legendary once your high-fashion pictures make their way into the schools in the form of wallet prints. This is what the kids hand out to each other to share their pictures. And yes, I realize the wallet-size prints will soon give way to everything digital like Facebook, etc. The point is still valid: The kids are single-handedly responsible for creating buzz for your studio.

Of course, this is a double-edged sword. You don't want to be that "creeper." The weird photographer, the one acting odd, saying weird things, giving the girls a strange vibe. You know the type of person I'm talking about. The kids talk. They talk a lot! We work hard to ensure they love their pics and everything about the process.

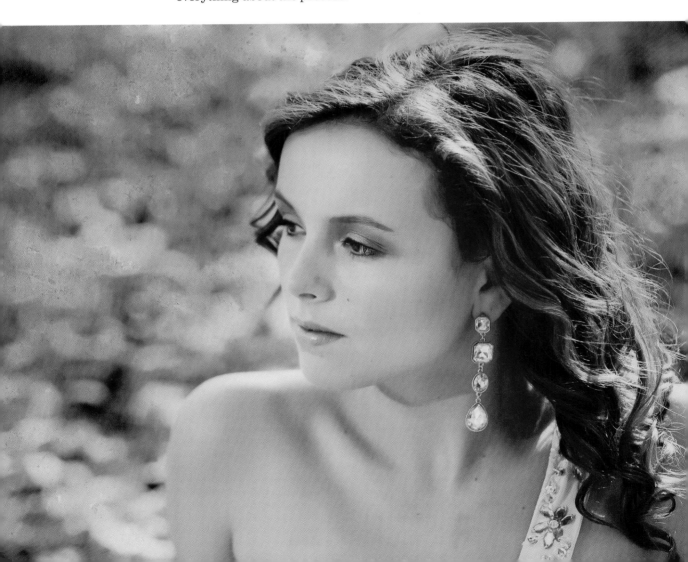

Guess who else talks? The parents. They talk to each other at sporting events, school events, and outside the school all the time. You're talking about relationships that have existed for years—in many cases, since grade school or middle school. You have to understand this dynamic if you're going to be successful. You also have to realize that while some of this may be tied to your photography, most of it is tied to you and your studio. In a word, it's about the "experience."

The Experience

My personal opinion? Nothing trumps the experience. And I mean nothing! You can be the best photographer in the world, and if you screw up the experience you can count on one thing—there will be buzz...about how bad you are. And this will be the beginning of the end.

Everything you do and don't do is tied to the experience. We'll explore this in detail later in another chapter, but like other aspects here, I want you to start thinking about the experience you're looking to provide your clients. Some cost money and others are about process.

My view is that the experience begins with that first email or phone call. How long do you take to respond? Once the clients get to the studio, how do you greet them? Do you provide hair and makeup? What experience are

you offering? Is it one that will blow your clients away, or is it one that's just "eh"? I promise you, there's no more important area to focus your attention than this. It will determine more than you can imagine. Provide a superior experience and you can charge whatever you like. People are willing to pay for better service. Provide an inferior service and you'll be scratching your head as to why you can't get clients to spend money in your studio.

For us, we provide our clients with a high-fashion model experience. That's our goal, and our clients respond to it. We're constantly enhancing and refining the customer experience. Be sure you start thinking about this, because it's extremely important that you give this the attention and resources it deserves.

Your Competition

Who freaking cares? Stop worrying about what everyone else is doing, and keep your own house in order. Focus on your business. Thomas Paine is quoted as saying, "Lead, follow, or get out of the way." I suggest you take this to heart in your business. The time you spend worrying about your competitors is time not spent on your own business. The next thing you know, the gap between you and your competition is growing and you can't figure out why. It's because you are not doing. You must be your own force of change. Control your own destiny.

That being said, I'd be lying if I said I didn't take a quick peek every now and again at my competitors. It's all about balance. Here's what I suggest you do. First, who are your competitors? List your top five competitors. What makes them your competitors? Shooting style, experience, or just that they have a camera? If everyone with a camera is your competitor, you've got bigger problems right now.

Start taking notes: What do clients like about your competitors? What's the biggest complaint they have? It's with this information that you can start putting together a plan of attack and determining what your studio will and won't do to stand out from the crowd. After that, move on and focus on growing your business and capturing market share. Force your competitors to follow you!

Defining Your Style

CREATING YOUR STYLE may sound easy, but you'd be surprised how many photographers out there have no clue what their style is. They try to be everything to everyone, and I'm here to tell you that is a failing strategy.

I'm not saying I figured it out on day one, but I've always been working toward it. I also can't sit here and profess that I've reached the finish line. My style is and always has been an evolutionary process. However, that being said, it has always been consistent. You might not understand at this very moment how important this consistency is, but when you think about it from a client's perspective, you'll easily realize that clients come to you for a certain type of photography.

When you try to be everything to everyone, you'll usually disappoint people. Instead, you need to work hard at defining your style. This ensures that you attract the right clients to your studio—clients who appreciate your artistic creativity.

And let's be clear. When it comes to defining your style, many things are involved. Posing, lighting, and post-production all define your style. Your shooting style should also match your brand. You can't have a soft flowery brand and then high dynamic range (HDR) editing with textures, kids lying in the middle of the street posed like they just came off the fashion runway, and so forth. It just doesn't match, and it creates confusion for your clients or potential clients.

This chapter discusses how posing and equipment can influence your style, and you'll see how I use these two techniques to define my style. Don't worry about whether you agree with my particular style; instead, focus on how you can hone in on your style using these same techniques for getting closer to finding "your" client.

Definition of Style

Style is one of those things that's very subjective. When it comes to fashion sense, I think you either have it or you don't. However, when we're speaking in terms of photography, I think it takes a different meaning. I'm not going to sit on my high horse and tell you my style is the best style or the only style. Far from it. I get frustrated when I see people with shooting styles that are all over the place and then they get confused as to why they can't get traction or access to the clients they want. That's because no one understands what you're all about. Whatever that is, it needs to be consistent.

Look, I don't love everyone's photography and I'm sure not everyone loves my photography. *I don't care*. Nor should you. What I do know and care about is the fact that my clients *love* my work. Love my eye. Love my edits. Love my posing. In fact, they're drawn to it. That's the key point here.

You have to work hard to coordinate every aspect of your business and ensure that it all points to the same brand and style.

So, where does posing come into all this? When I started out, posing was one of the toughest things for me to gain an understanding of. Actually, I think confidence would be a better word. I had no confidence in my posing ability. I kept trying things, and I don't know, it just seemed awkward. Awkward for both me and the client. Some subjects will do just fine posing themselves whereas others are a mess. They have no idea what looks good and what looks bad. When they come to see their pictures, they'll let you know what they think with the way they do or don't spend their dollars. Problem is, by that point it's often too late.

I knew I had to figure this out. In the beginning, I was so insecure that I'd have the client or their parents trying to tell me how to pose them. People feed off that insecurity. They smell it. I couldn't have that. Today, that doesn't happen at all. In fact, I was on a shoot somewhat recently and had a parent try to continuously interject and adjust her daughter's pose. I asked her once nicely. I said, "Hey mom, you came to me for a reason, you have to let me do my thing." She nicely said, "Okay, I'm sorry." Thirty minutes later, this was still going on. Under most circumstances it probably wouldn't have bothered me so much, but at this point she was now making her daughter self-conscious. So, with her next adjustment and comment, I offered her my camera. I said, "Here you go, mom. I think you want to drive this shoot." She looked at me, apologized, and went to the car.

Now, some of you might be thinking, "Damn, that's harsh" but others have probably wanted to do just that and more to an overbearing parent. Here's why I'm sharing this story with you. It was confidence that allowed me to do that. Confidence that I knew what I had to do to deliver what the client expected. I knew what the client expected because every aspect of my work, my website, my brand, my editing, and my posing matched what the client saw when they hired me. There was no way the client could come in after the fact and say they were unhappy. However, if I were trying to make everyone happy, clients wouldn't have a clear understanding of my style and that would lead to all sorts of missed expectations.

I know I'm really emphasizing this point, but it's a critical one in your journey to finding and connecting with the right clients.

Style is your vision. Own it. Be confident in it. And always looks for ways to evolve it.

My style of posing definitely has its own feel to it. I think it has a modern fashion feel without being over-the-top high-fashion weird. I'm definitely influenced by fashion, and so are the kids. That being said, guess what you'll never see me do? Traditional poses. It's just not my style. So my clients would never expect to see it from me.

Balancing Act

When it comes to posing, you have two clients you're trying to please—the kids and the parents. And they aren't always on the same page. Actually, I'd say they aren't on the same page 80 percent of the time. This is why posing is so important. I have to push the limits without crossing the line. Sounds easy, right?

In our studio, the number one selling item is a three-quarter headshot. The moms go bonkers for this. And it's ordered in a 16x24 canvas 90 percent of the time. No matter how many other types of shots and poses I show, this is what they want. They've seen it on our website, at their friend's house, on Facebook, etc. It's what they expect. Consistency.

Sure, I try the big dramatic shots we're known for with our wedding clients, but the moms just want to see their kid's face. It's a must. The kids, however, love the dramatic shots. They go bonkers for them. Well, there you have it; I have two clients to please. I am okay with that. It's more about being aware of it, so that you can plan for it and shoot for it.

Moms control the money. Kids control their parents. Dads want mom and daughter happy. Are you starting to see this madness and how it works? Just be sure when you're working on all this you're considering not only what the kids want, but the overall needs of the family.

Oh yeah, and by the way, what about what you want? See, our style has to evolve or we get stale. This is very important. Here's what I have done and had success with. When it comes to seniors, 95 percent of what I do is repetitive; it's a formula. As it should be to a certain extent; this is what they're hiring me for. But take that remaining 5 percent and make it yours. Who cares if they buy anything from it? Do it for you and your portfolio. Now, here's what will happen. As you start building confidence and you see your clients buying these images, this "5 percent" that you were shooting for yourself will start to naturally make its way into your style and to your website. I guess, in a sense, you'll be keeping everyone happy, yourself included.

In Studio vs. On Location

When it comes to posing, you have limitations depending on if you're located in studio or on location. Again, this is all based on my personal experience. There's just something about being in a studio on a fake background that just screams "lame" to me. Again, this is just my personal opinion. When we first opened our studio, we offered an in-studio option and I just didn't like it. There are a lot of ways to introduce props, but again, that approach didn't match my style of being a little more urban and grungy.

If you're going to do in-studio work, you need to learn lighting. Studio lighting. Not natural light. To me, shooting only natural light is code for "I don't know crap about lighting." Figure it out. You're a professional photographer. Invest and learn. Now, that being said, I just want you to start thinking about lighting and your options. I'll show you some next. As it pertains to your style, you must use various lighting techniques to stand out from the crowd.

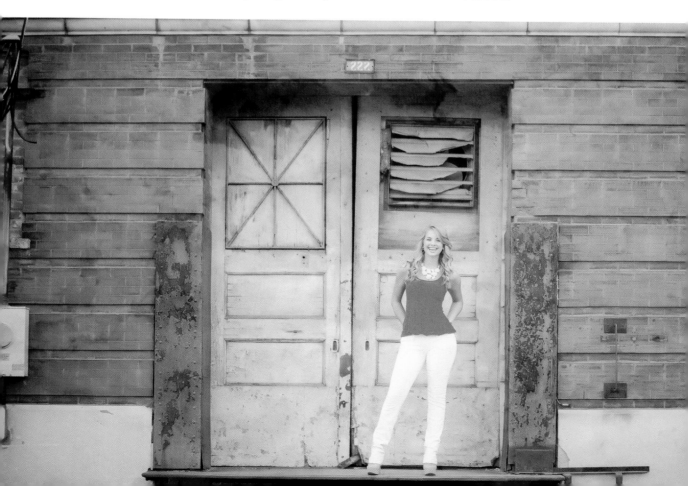

I find that when it comes to posing in studio I struggle with full-body portraits or anything overly dramatic. If you've looked at my work, you know I love the dramatic portraits. Big and architectural in nature. That's my style. I find it almost impossible to deliver that look in the studio.

Location shooting is no easy task either. You're dealing with the elements. Lighting controls you; you just live in its world. Again, you can try to be a natural light photographer, but that's going to limit your style. You still need to learn and understand lighting. This is something we'll drill into more in the next chapter. When it comes to posing, for me, there's no limit whatsoever. I can sit them on the ground, lean them on a wall, have them walking down the street, and if I don't like the backdrop, I can drive down the street where I can find a new backdrop and change the entire mood of the portrait.

Tight. Middle. Wide.

This is my mantra when it comes to shooting. And simply put, it's about getting as many different looks as you can from a single pose. This gives your clients the most options. There's no reason you wouldn't shoot this way. Give your clients options and your sales will follow. Something that drives me nuts is watching photographers work. They walk up to a scene. Get the client posed. Snap an image or two and move on to the next pose. *Ahhh!* Your client is standing there, comfortable and ready to go. Use your lens or use your legs. Tight. Middle. Wide. Vertical. Horizontal.

Here is what I mean. Ninety percent of the time I'm shooting with a 70–200mm lens. Tight = 200mm. Middle = 120mm. Wide = 70mm or switch lenses and go super wide with a 16–35mm. Then get both horizontal and vertical. Without moving the client and with a single expression, you can get six different frames. Add different expressions and poses and the number of unique shots explodes.

This system takes practice. There's no doubt about it. But once you get it, you get it and this becomes your rhythm. Once you have this rhythm, this too becomes part of your style.

Okay, so let's take a look at some imagery next.

Studio Work

From time to time, I still shoot indoors. I'm not against it; I just don't love it. However, I still know what I'm doing. We have to perfect our craft.

Here's what I work with today in the studio:

- ▶ Alien Bees strobes (400 and 800)
- ▶ Softboxes
- ▶ Light stands
- ▶ Triggers
- ▶ Light meter
- ▶ Beauty dish
- ▶ Ring flash
- ▶ Grids

Clam Shell Setup

Here are some samples to look at (**Figures A–D**). In this first shot, I'm using a clam shell setup. One big softbox above and one thin softbox below on a black background. In addition, I have a rim light behind the senior to create separation from the background. You can see the difference in the two shots.

This is a very even light setup creating a gorgeous light for beauty work. I typically have both lights on the same power setting or the bottom light set ¼ stop less power than the light above in order to create a bit of dimension.

A The clam shell setup

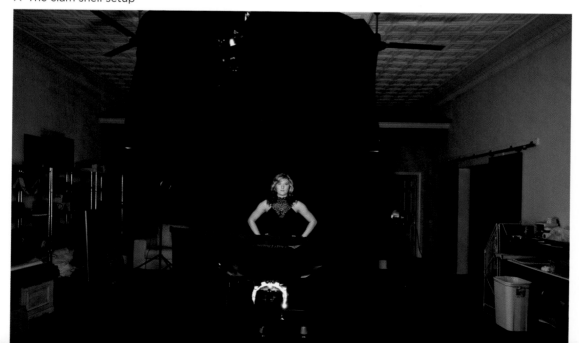

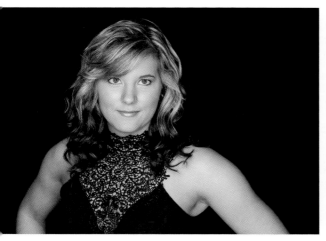

B Clam shell image without rim light

C Clam shell image with rim light

D Clam shell image with rim light

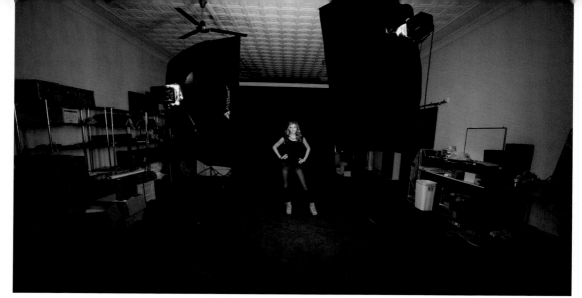

E The main/fill setup

Main/Fill Setup

The next option is a standard main light/fill light setup (**Figures E–H**). I typically have these at the same power settings again. For beauty/fashion work, you aren't looking to create too much dimension. This is personal preference. You have to get in there and experiment. You could set up your main light and then have your fill light up to one stop less power to create some dimensionality to your portrait. Find your style—experiment.

Then, you can turn off the fill and just use a single light to create a unique look.

F Main/fill image with rim light

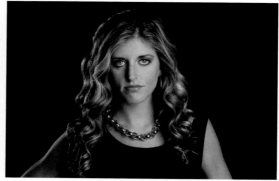

G Image with main light (no fill) and rim light

H (opposite) Image with main light only

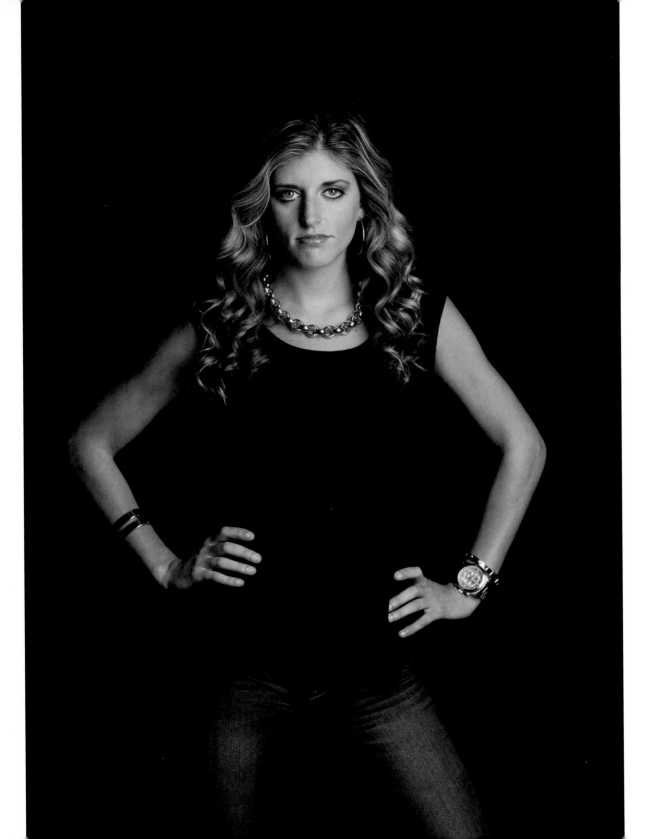

I Beauty dish

J Beauty dish image with rim light

K Beauty dish setup with rim light

Beauty Dish Setup

The beauty dish is common in the fashion industry. It creates a beautiful wrapping light. They come in all shapes and sizes and all price points, as you can imagine.

Here are some sample images in the same studio (**Figures I–K**). As you can see, it creates yet another different look. Are you seeing how these different looks start to define your style?

Ring Flash

The ring flash is a fashion staple, and I love using it for unique shoots with my seniors (**Figures L–N**). I don't think this is for everyone, but without a doubt it's going to introduce a high-fashion look to your session, and once again it will define your style. Usually when I'm working with a ring flash, it's the only light source I'm using. It has a very distinctive look.

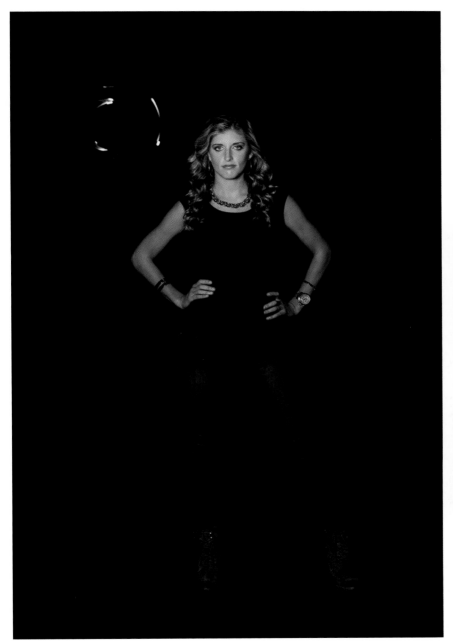

L Ring flash setup

M Ring flash

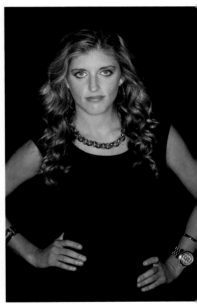

N Ring flash image

That's it! That's all I use when doing studio work. This isn't a book on lighting and lighting ratios. A ton of books are available that do a much better job explaining all that than I can here. There are a lot of things to consider when you're working in a studio. If you're just starting out, I'm sure it can seem overwhelming. In the next chapter, we cover some on-location lighting techniques as well.

I'll say it again: If you want to take your skills to the next level and be more than just a natural light photographer, you've got to learn and understand lighting of all kinds and sources. Without light, we can't make an image. Light is your best friend.

On-Location Work

On-location work is where I shine. This is what I'm passionate about. I love on-location work. It's just something new and different all the time. It lets me incorporate all the elements and do my best work.

Here's what I used for the images shown in this section: 70–200mm f/2.8 lens and a reflector. *That's it!*

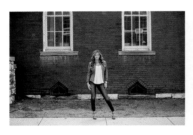
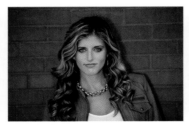
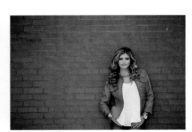
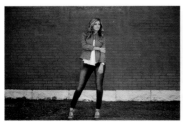
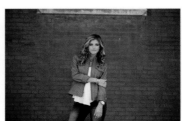
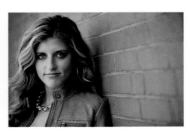

In my heart I'm a run-and-gun shooter. There's no reason to make a shoot last longer than it needs to. It makes clients nuts. They get bored. I've had countless clients thank me for making it so much fun and so easy. Do you know what they really mean? Fast! We get all these amazing images without goofing around with equipment. We never let the equipment get in the way of the shot. Sure, on a commercial shoot, we may spend three hours setting up lighting for a three-minute shoot with a celebrity, but in the world of high school seniors, that just won't work.

Here's what I want you to pay attention to when you're looking at these images:

- The unassuming location—nothing special

- Variety in focal length

- Variety in poses

- The fact that this is a single location

- A consistent style

Don't overcomplicate things. Complicated does not equal good. I'm not trying to justify my value with my clients by introducing complexity. I want to move quickly and efficiently and ensure that my client—the senior—is having a blast in the process.

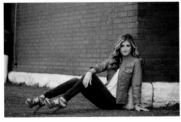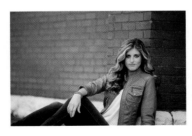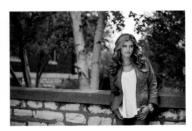

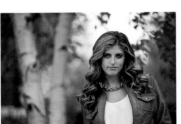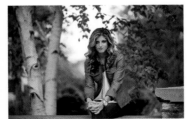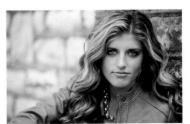

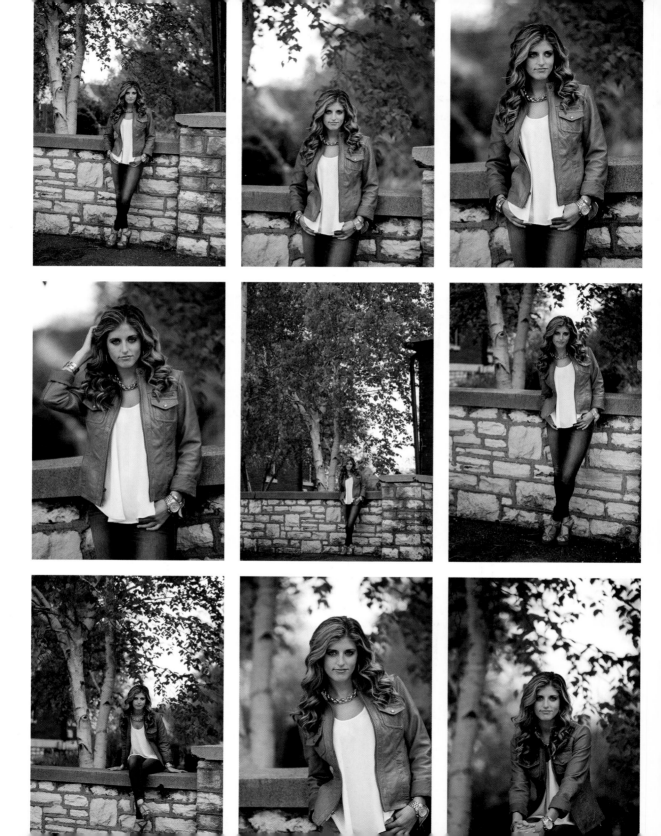

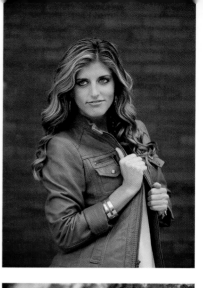
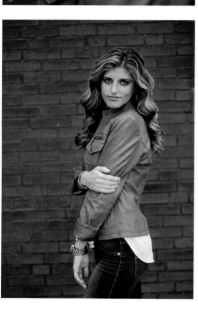
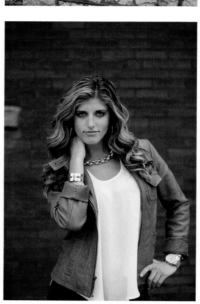
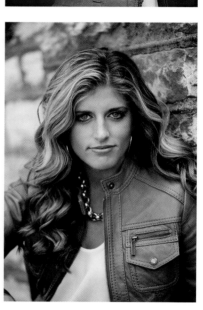
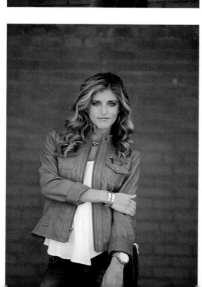
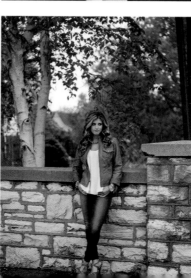
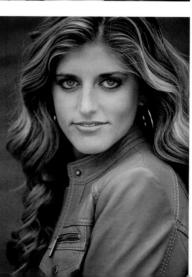

Next Steps ▶▶▶

So, you might be wondering, "Where do I go from here?" I stressed it earlier—you have to figure out what your style is. There's no other way to do it except to get out there and shoot. With that being said, style isn't something that should ever be static. It will change and evolve, but it should be consistent. You can use posing, lighting, locations, and editing to define your style. We'll explore more of those topics in later chapters.

Here's what I want you to do. First, I think about what you'd like your style to be. If we lived in a perfect world and you could do anything you wanted, what would that look like? This is something you should be asking yourself even if you're an established studio. Next, I want you to think about what image you're presenting to your clients on your website, marketing material, and other material. What do your clients see? Is it consistent? Ask them! They'll tell you the truth; you just have to be willing to listen. And finally, close the gap on where you want to be versus where you are today. Find your way, experiment, and present to the world your work as an artist. Once you do, I promise, your work will begin to stand out and you'll be on the path to a successful senior business.

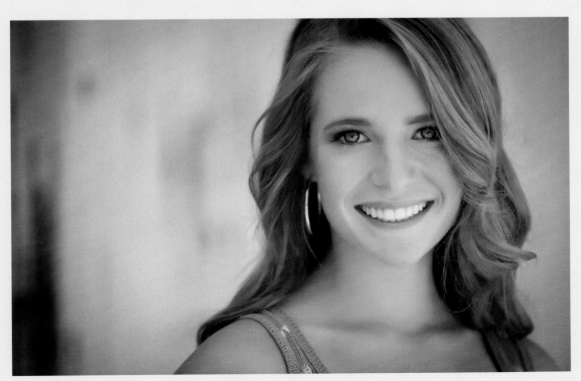

three

On Location

SHOOTING ON LOCATION doesn't mean you can use only available light. Remember what I said in the previous chapter—that's code for "I have no freaking clue about lighting." That's fine, I suppose. There are a lot of natural light photographers in the world, but if you want to take your imagery to that next level, you need to understand the various options when you're on location. That being said, I don't want anyone to believe that on every session I use all these different lighting techniques. Not true at all. However, there's no situation that I'm uncomfortable in: rain, shine, direct sunlight, open shade, indoors, mixed light.... I know I can rely on several lighting techniques to get the look I want.

By understanding light—how to manipulate it, block it, work with it, enhance it—you create a look that's unique to you, and you build confidence in your ability to deal with any scenario out there. Confidence is something all artists need and crave in order to do what we do. Trust me on this. There's more to photography than being a natural light photographer. It's like shooting with one hand behind your back. It makes you a one-dimensional photographer. Invest and experiment with lighting and it will open your eyes to a whole new world.

Natural Light

I hope you didn't misunderstand me when it comes to natural light. I'm not trying to be an elitist when it comes to light. I'm merely suggesting that natural light is the basic 101 course of lighting. Of course, I love nothing more than showing up to a scene and seeing some gorgeous natural light. The golden hour. We all love it. The light is perfect. Sitting there on the horizon providing gorgeous warm tones. The problem is, it's only there for one to two hours a day. What do you do the rest of the day? Not work?

If you are working with high school seniors, you have to be able to push 3–5 shoots per day. We start at 9 a.m. and go until 7 or 8 p.m. when the light will allow. That means I must be able to shoot in the harshest of lighting conditions. Don't forget: We're in this business to make money. Yes, I want to make amazing images for my clients, but ultimately I need to be able to find a way to do it under any lighting conditions.

Natural light is a luxury. Use it whenever you can. Modify it by using reflectors and scrims. Natural light can be your friend but also your enemy if you don't work with it in the right way. Natural light alone can leave your images looking flat, and that's never a good thing. We all want our subjects to pop off the background. Let's look at ways to make that happen.

Reflector

You should never leave home without your reflector. It's both lightweight and portable. You can find reflectors in all shapes and sizes and, of course, all price ranges. I don't want to turn this chapter into a product review. Find an online retailer like Adorama.com and check out the plethora of options. Your best bet is to get a 5-in-1 reflector. This reflector has silver, gold, mixed, black, and a scrim all built into one, which is important to me because I like to be lightweight. I'm not a huge fan of equipment getting in the way of the shot or just adding extra people and bags for the sake of it.

How you light your subject using the reflector is a bit of an art form in and of itself, and it comes down to the look you're striving to achieve. For me, I use silver 100 percent of the time. I like it because of the harsh nature of the light it throws. Again, this is my style. Figure yours out and be consistent with it. Your clients will start to notice your look.

In the images shown here, you can see how we create one of our signature headshots for the kids. This is one of the most requested shots we get from parents. They love these shots. Well, as you can see there's nothing to it. I have the senior in open shade and the reflector is right on her lap (**Figures A** and **B**).

A Using a reflector for a signature headshot

B

C (opposite)

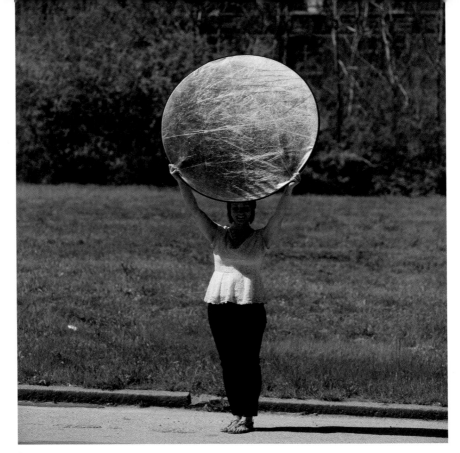

D

I love the simplicity of this setup. It's super easy to implement and gives me a look I like.

Let's take the reflector a step further. The specular nature of the silver side throws hard light when put in direct sunlight.

In this next pair of images (**Figures C** and **D**), you can see my assistant Alissa standing across the street holding the reflector above her head and throwing the light across the street. The other image shows the end result. You can see the shadow being cast on the wall behind our senior.

There are two primary advantages I see when using a reflector. First is the lightweight and portable nature of the light source. Second is the ability to see exactly what the light looks like on your subject before you ever make an image. This ability saves you tons of time setting up a shot and keeps the shoot moving at a good pace.

However, there's a major disadvantage when using a reflector. What do you do when the sun isn't out? You are out of luck, my friend. So you better start learning how to use additional light sources or your images will just look flat.

Scrim

Using a scrim is a great way to soften the light. Typically a scrim will lose about a stop of light, and that's usually just fine, but it allows you to work in the harshest of conditions and create a nice, soft light source.

Figure E shows our senior in the middle of the street during the middle of the day. The light is *awful*. Just completely unusable.

E

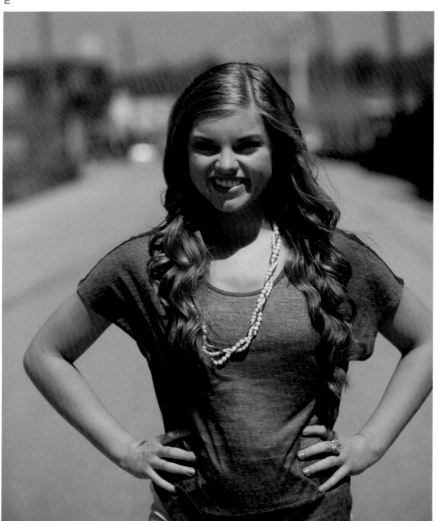

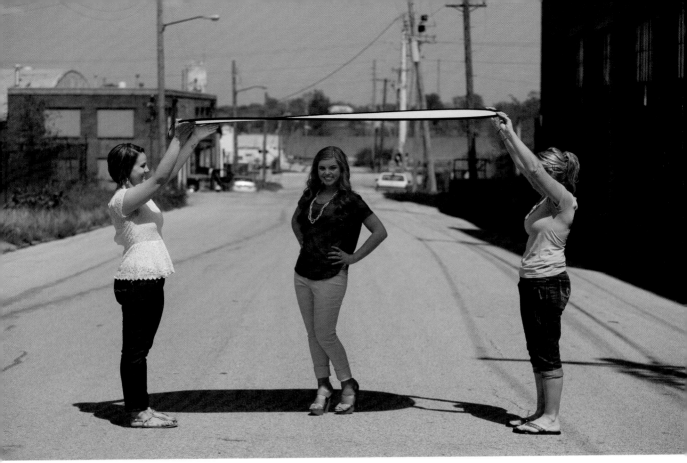

F Using a scrim softens the light and allows you to work in any harsh lighting conditions

Bring in the scrim!

These next images show the scrim in action. Grab the parents, your assistant, a stranger on the street to help out. The scrim will immediately soften the light and allow you to work in any condition (**Figure F**).

Figure G shows the same shot as Figure E except now I'm using a scrim. Now, I know what you're probably thinking. "Sal, the lighting still sucks." 1) Yes, it does. 2) It's a hundred times better than without the scrim. It allows me to work at midday.

What would make it better? A reflector! Yes, let's bring in the reflector so we can now light her up and fill in those shadows.

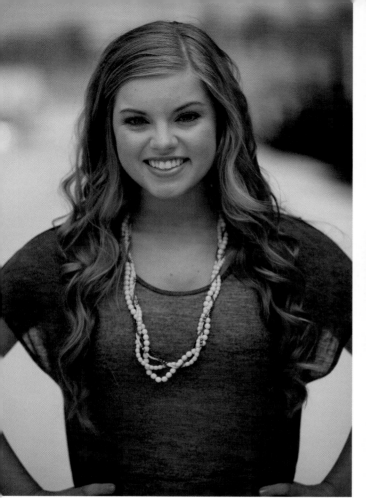

G

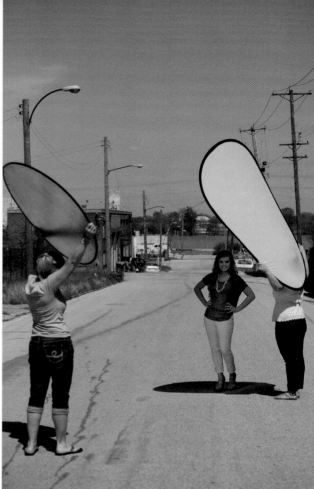

H Using both a reflector and a scrim

Now we've got a combination of the scrim and the reflector at work (**Figures H** and **I**). To achieve that, we had to change things up a bit in the roles and responsibilities department.

Check out the setup shot in Figure H to see how we accomplished this. Alissa took over the scrim and mom took over reflector duty. Yes, I put mom to work. And she loved it! This is an experience for everyone. Our clients are having fun participating in the process of making their son or daughter look gorgeous.

Don't underestimate the power of the scrim. It's a powerful tool that's underappreciated and underutilized. The benefits should be obvious.

I (opposite) The final result

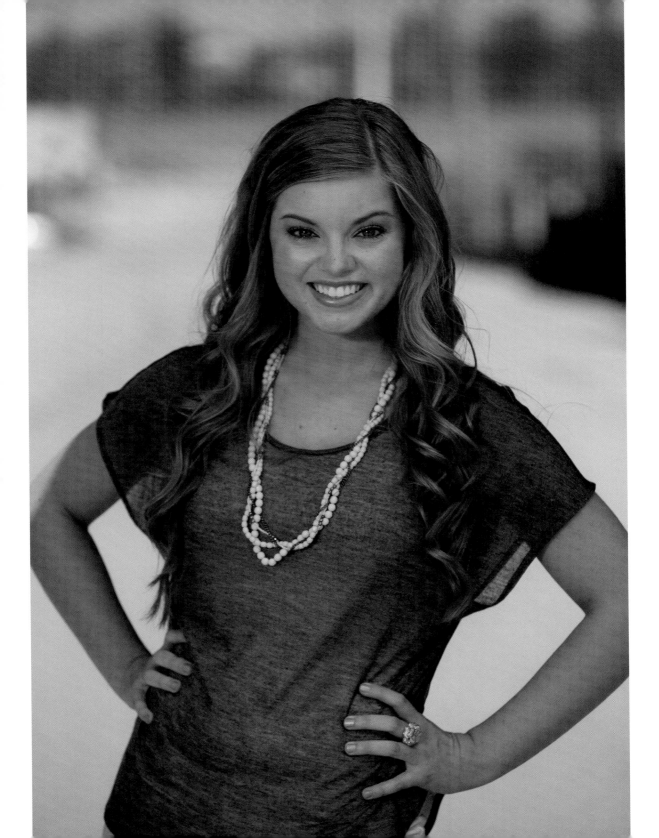

Off-Camera Flash

This conversation often strikes fear in the heart of photographers. I cover this topic in every workshop I teach. It's so easy, yet so complicated. My job is to dummy-proof it for my staff and, of course, you.

Learning about off-camera flash is just about building confidence and getting out there and practicing. Once you do, I think you'll truly understand the power of incorporating off-camera flash into your portrait sessions.

Here's the thing to consider. Keep it simple. First, you're going to need some sort of triggering mechanism in order to fire the flash. When it comes to flash, I almost always use my speedlites (small hot-shoe flashes). Regardless of whether you use Canon or Nikon, they have speedlites. (Canon calls them Speedlites and Nikon calls them Speedlights.) Why is this so important? Because I want to use a feature called ETTL—Electronic Through The Lens Metering. That means all the work of determining how much light to put out is being done by the camera and its metering system that the camera manufacturers spent millions of dollars on.

You have several options when determining triggering methods. The speedlites have infrared communication. That means they can talk to each other without the use of a third-party trigger. However, infrared communication has limitations. The first is that bright light can interfere with communication. Second, the distance between your camera and the flash is limited. The third factor is line of sight; the units have to "see" each other to talk. Check your flash manufacturer for all the specs, but know that these are some of the issues you'll run into.

Canon, with the Speedlite 600EX-RT, has introduced radio transmitters that are built into the unit. This fixes several problems. First, brightness is a nonissue. Second, the distance increases to almost 1500 feet. Third, line of sight is not required. Very cool for more creative lighting setups.

That being said, many third-party manufacturers make triggering systems for the speedlites. Some support ETTL, whereas others don't. The end result is the same—a portable light source producing big results.

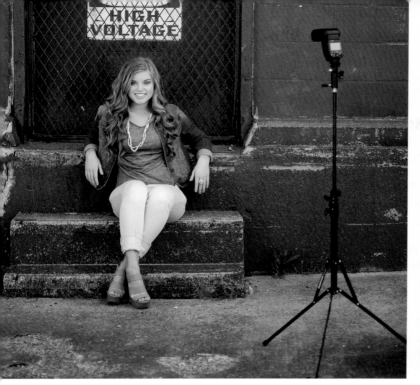

J A quick one-light setup K

In **Figure J**, you can see we're using a Canon 600 Speedlite and a Manfrotto nano stand, which collapses to less than 20 inches in height. This is an extremely portable system for photographers on the go. And check out the resulting image (**Figure K**). This is shot with no light modifier whatsoever. This is just a straight speedlite. And I love it. We'll talk about some modifiers I use a little later, but there's just nothing wrong with this light. It's gorgeous.

In this example, our senior is sitting in open shade. So, the truth is that this is an easy example of using off-camera flash; there's nothing magical going on and the camera and its metering system are easily making the correct decisions.

Let's look at a situation that might be a little more challenging—direct sunlight. Gasp! "Shooting during the middle of the day is just pure craziness, Sal. I wait until the golden hour." Well, once again, I'm here to tell you that if you want to make real money in this business you have to shoot all day in any condition.

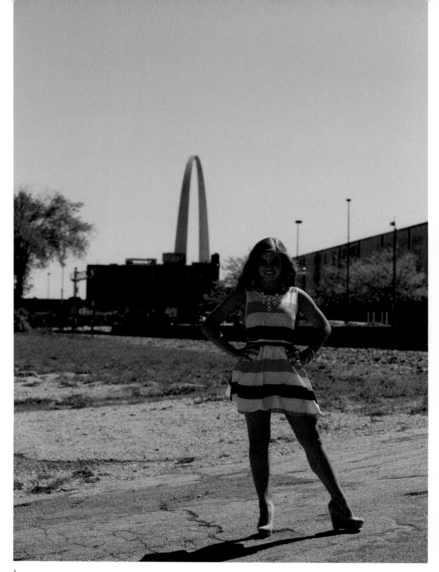

L

M

So, here we are in direct sunlight (**Figures L–N**). I took our senior and positioned her so that I could use the sun as an edge light. I'm not running from the sun; I'm using it as a light source. As you can see in Figure L, everything looks about right except for the senior. Her face is underexposed. Sure, I can try to fix this in camera or in post-production, but the truth is, I'll blow out the sky if I expose for her face. And using post-production as my crutch just costs me more money and time. Well, we're in luck. Let's pull out that speedlite again and create some directional light.

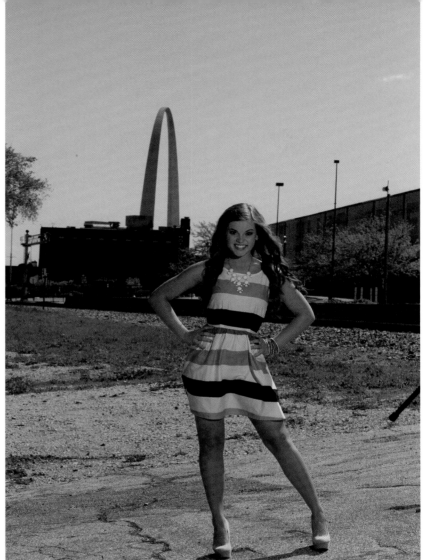

N

In Figure M you can see Alissa off to camera right giving us some directional light. As you can see in the resulting image (Figure N), the senior is now well lit and the blue sky is still intact with great color. This is how your images will begin to stand out from the crowd. This took me less than two minutes to get the equipment out of the trunk of my car and set it up. Using ETTL is a great way to keep it simple and still get great results. Sure, you have other options, but this is how we do it. I never want my equipment to get in the way of the shoot by overcomplicating things.

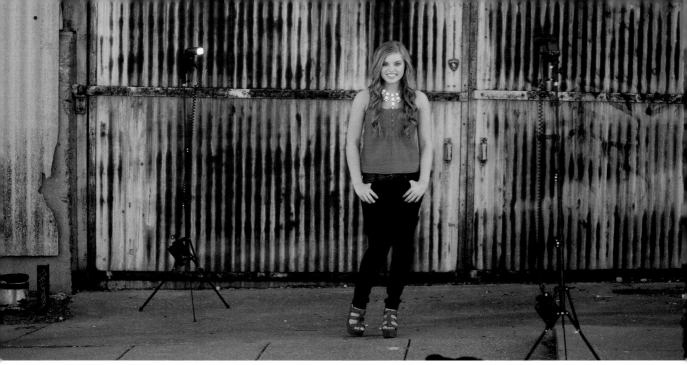

○ Two-light setup

Two-Light Setup

Okay, so let's shake things up a bit here and go with a two-light setup outside. Remember, I'm trying to show you ways to stand out and take your work and look to that next level. Keep it simple and get out there and practice.

Here we've got our senior in open shade on a cool tin background. For this particular shot I wanted to create some separation from the background. So, I brought in another light, again using ETTL. In **Figure O**, you can see we're also using battery packs to power the speedlites. If you've ever worked with your speedlites and got tired of waiting for what seems like an eternity for them to recycle, you'll appreciate this option. The battery packs allow the speedlites to recycle in less than one second. For me, this is very important because it lets me maintain the tempo of the shoot.

Check out the result (**Figure P**): a gorgeous shot with great separation from the background. Once again, I need you to understand this took less than three minutes to set up. Once you get a setup like this, you'll realize how quickly you can set up and break down. Could I have taken this shot with no flash? Of course. But it'd never have looked like this.

P (opposite)

Light Modifiers

Okay, so we all like our toys. And who doesn't like playing with some light modifiers? There are a ton of them on the market. I mean a ton! I'm not going to endorse one over the other; just keep in mind that it's all about adjusting the size and quality of the light. I've played with a lot of different light modifiers, but none better than those provided by Rogue. Yeah, I know I just said I wasn't going to endorse any, but these are my favorite. I love the quality, durability, and portability of their products. They fit right in my travel bag and take up little to no room. And they break down completely flat.

Figure Q shows a Rogue softbox for your speedlite. It attaches in seconds to your flash. In this scenario, I had Alissa handhold the unit in order to get the light where we needed it (**Figure R**). We had to get the light under the rim of the hat.

Q

R

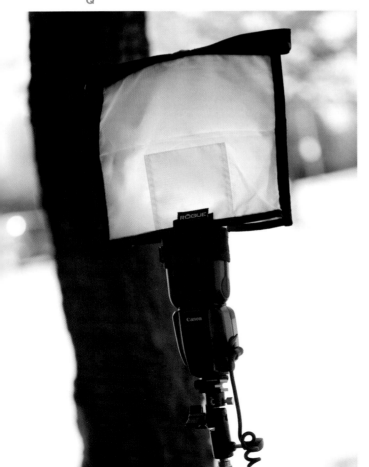

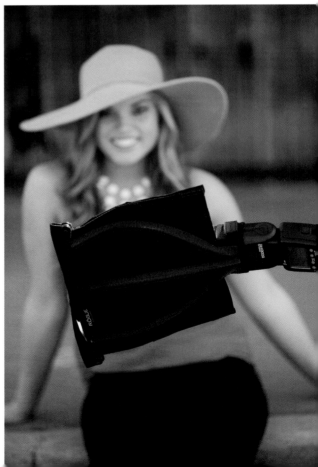

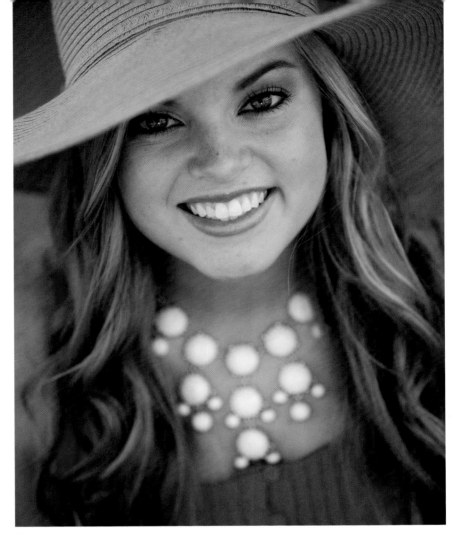

S

Could we have shot this with available light? I suppose. However, we would've had some dark shadows across her face where the hat comes down over the eye. Could we have shot it with a flash and no modifier? Again, I suppose. However, we would've had a very hard light source creating harsh shadows where the rim of the hat is.

It's all about having the right tool for the job. In this case, I went to the bag and pulled out this lightweight and portable modifier.

In **Figure S** you can see the gorgeous result: a nice soft light that looks natural and makes our senior's eyes pop.

T

Gels

Gels are those things you put in your bag sometimes because you think you're supposed to have them, but you never know when the hell to use them. Well, I wanted to show you how to do something a little different. Consider this an experiment.

I carry gels in my bag but use them in very few situations. This is one of them. Let's say you want to cool an image down...maybe make it look like nighttime is approaching. Here we're shooting during the middle of the day, so we need to cool down the sky in order to accomplish this. So I pull out the awesome gel kit from Rogue that sits right in my bag (**Figure T**).

Here's the technique. You're setting the white balance on your camera using kelvin. If you don't know how to do this, check your manual. The white balance on the camera should be balanced to the sky. In this case, I wanted the sky to be cool to look like night was approaching. I set my kelvin to 3900. Take a test shot with nothing else. Your image will look extremely blue. This is a good thing.

Now, I don't want my senior to be blue. So I need to warm her up a bit. This is where the gels come in. I will use a ½ CTO gel, as shown in **Figure U**, to light my subject. The warm gel offsets the cool blue white balance, which will allow me to get her skin tones right and the sky to remain that cool blue (**Figure V** on the next page).

Again, this is a cool way to easily introduce something new to your portraits.

U

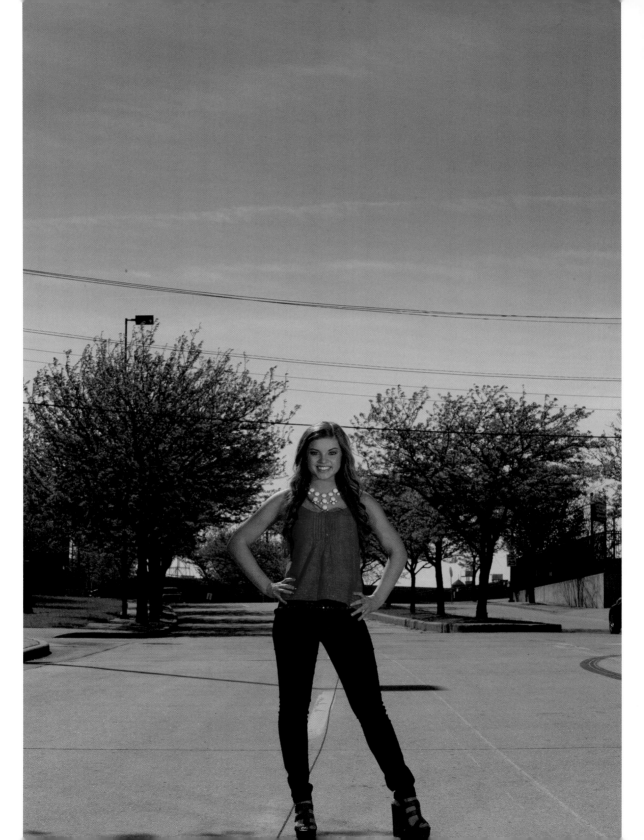

Next Steps ▶▶▶

Everything I've covered in this chapter contributes to that wow factor people talk about. They can't explain why your images look different; they just know that they do.

So, where do you start?

▸ Start by accepting that you're going to be more than a natural light photographer.

▸ Get out there and practice with the multitude of light sources at your disposal. Learn and understand that light is your friend. We need it to make images.

▸ Beg, borrow, and plead to get the equipment you need if you're starting out. I just want you to become more and more familiar with the various lighting techniques so you can develop your own sense of style.

▸ Practice on nonclients. The last place I want to practice is on paying clients. They don't have tolerance for mistakes. Cut your teeth someplace else. Somewhere that you aren't rushed and have time to think about what's going on or why a certain light setup isn't working. We have all been there—starting to panic and freak out, either never getting the shot we wanted or just making the client nuts as they wait for us to figure it out.

▸ Don't be afraid to try something different.

∨ (opposite)

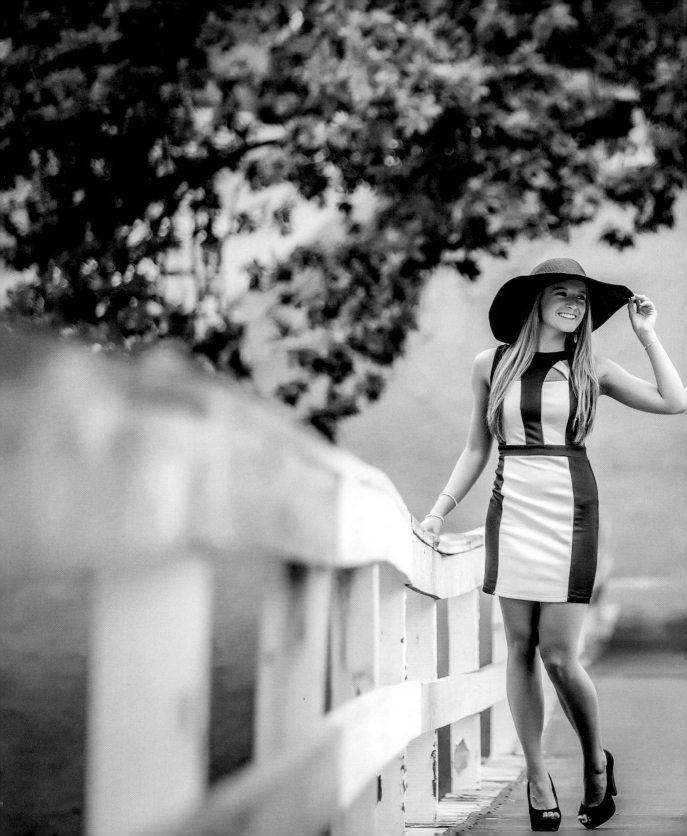

four

Post-Production: Where It All Comes Together

FOR MOST PHOTOGRAPHERS, post-production is all too often an afterthought. However, if you're looking to be successful, post-production has to be something you're thinking about at all times.

In fact, when it comes to post-production, I'm often thinking about it during the shoot. We should be using all the tools made available to us to create the best possible photograph imaginable.

I run into a lot of purists who think that too much post-production work—or Photoshop work, as they refer to it—isn't presenting the image the way it was captured. It's embellishing it to a certain extent. Well, maybe they're right, I don't know. I say, if that's your philosophy, then why use a digital camera? Why don't we go back to the days of 20-minute exposures? Technology is here to stay, and it evolves and advances constantly. I'd want to embrace it and use it to enhance my art rather than limit what I can produce.

Can you imagine if we limited some of the great artists of our time to using certain materials to create their art? Reading what I'm writing, it sounds absolutely ridiculous! As it should be.

When we create an image using our camera, I am of the philosophy that that's just the beginning. We need to use the tools available to us to finish this product all the way to the printed image. Post-production is an important step in the journey of your imagery.

Throughout this chapter, I have included pairs of photos showing each shot's Before and After image for you to use for inspiration and to get a sense of what's possible with your imagery when you choose to take your images further than what you get at the time of capture.

Out of Camera

No matter what kind of camera setup you're using, your images out of camera are just not that good. This is the world of digital. Your images need to be processed in some form or fashion in order to polish them.

The key here is understanding that when you're capturing and creating imagery, you have to start thinking about the next step in the process. How will you edit this image? Will you convert to black and white? Will you do beauty editing on it?

I've seen studios all over the country—mostly older studios—shoot 30–50 images for their high school senior clients and show them immediately on a screen while they are there, or bring them in days later only to look over unprocessed images as proofs. Not only that, they charge for different editing styles. Yep. You read that right. In my local market there are some older studios charging $5 to convert an image to black and white. I laugh every time I see this.

Seniors are a very finicky demographic. You'll hear me talk about this over and over again. They want to look hip and cool! Looking at unprocessed images and having to visualize what it might or could look like—and then having to pay for it by the image—is utterly ridiculous!

Clients don't have vision! That's why they came to you. You're the expert. You're the artist. You should show them how this piece of art should look. It's not an a la carte menu of editing. If you think it should be a sepia-toned image with heavy texture—*show them that*! Stop being lazy. That's all it is. You realize that, right? It takes work to make these edits. And in the end you don't know what they'll buy. Very true. However, you know the saying, right? "You gotta show it to sell it." Well...why would this be any different? You want a client to buy this large grandiose image, but they should first visualize how cool it will be?

Today, these kids want to see what they see in the magazines, online, on Instagram, on iPhone apps galore, and their own computer editing software. Today's kids are tech savvy. You think you're going to impress them with what comes out of your camera? Good luck with that.

At the end of the day, it's lazy and it's an incomplete product or service you're presenting to your clients. You have to finish the job you started.

Your camera is a tool. It's one tool in the overall process of creating a great image. Please don't make it the last tool. Ensure that your mind is right and that you understand, at this stage of the process, that you should be focusing on proper exposure, impact, and composition. That is foundational to creating a great image.

The Value of Post-Production

Everyone is a photographer today! I mean everyone. So what's the difference between you and everyone else? Oh wait, you have a better camera? Hold on, I almost choked on my food. Wake up, photographers around the world! Gear is no longer a barrier to entry! You can make a decent image with your iPhone today! They just introduced a 40-megapixel camera phone. That's reality. Nothing you or I can do about it. You don't have to be a nerd anymore to understand film, lighting ratios, or any of the other complexities you had to understand back in the day to be a photographer.

In fact, there used to be a time where there was no such thing as autofocus. You had to manually focus your camera. *What?* Is Sal crazy? Yeah, you even had to control your exposure manually...*gasp!!*

Now, I'm not an old bitter photographer. I just understand our history. Trust me, not a single part of my being wants to go back to the days of old. I love the way things are today, and I'm always looking toward the future. Technology is my friend. However, with innovation has come the nonexistent barrier to entry. So, now, everyone is a photographer. We have to take the good with the bad, I suppose.

That is where post-production comes into play. Although camera companies have made it easier to create a great image, you still have to process that image. Turn it into art. That's the competitive advantage we all have. There's no reason for you not to invest in this part of your business. You can do it yourself or outsource it. We'll discuss more on this later; just keep in mind you have options.

Start thinking about post-production in terms of branding. The way you finish your images can and will define your brand. For us, people recognize our imagery through our editing techniques. As crazy as that sounds, the post-production is something that allows us to stand out from the crowd and it helps define our brand. We want to be fashion forward; this is very powerful. It allows our studio to set the tone of imagery in our area and it forces other studios to follow our lead. This can be huge for business. Are you a leader or a follower?

This also has some amazing positive side effects with clients. It's difficult to charge more for your product or service if your clients don't see any discernible difference in the product or service you're offering. How many of you feel like your clients just see you as a guy or gal with a camera? That's on you! This is our fault. It's because we are not completing the job we started with our clients. We are, in essence, just a camera and if I haven't bludgeoned you enough yet, we can't compete on gear! Everyone has access to it.

So, what do we do? Post-production allows us to truly start differentiating ourselves in a meaningful way to our clients. They're going to see the difference and value of a normal image compared to a polished image. They might not be able to articulate what the difference is, but they'll feel differently and they'll spend differently. I guarantee it.

Today, clients are numb to basic editing. They can do all this on their own in their fancy iPhones and Instagram-style apps. You're not going to impress anyone if you don't take it to the next level. One of the biggest challenges out there today are the clients who want nothing but digital images. We don't get a whole lot of that. We don't offer digital negatives to our senior clients at all. It's not even an option. We own the process and the final product. We explain this to our clients. If you're looking for a digital file, we're probably not going to be a good fit for you. We spend too much time perfecting each image that leaves the studio, and we just can't do that to every image and hand that over on a DVD. We wouldn't be able to stay in business. Ninety-nine percent of our clients understand this and respect it. Bottom line, it's true.

We color-correct each image along with beauty edits, skin softening, sky swaps, texture overlays, and so forth. These things take time and they aren't easily reproducible. This gives us a distinct competitive advantage and separates us from every other person with a camera. My clients want artwork, and that's what we show them and deliver to them.

Don't underestimate the value that post-production can add to your brand and your financial bottom line.

Do It Yourself or Outsource It?

If you're like most artists—and like myself, for that matter—you're a *control freak!* No one can edit your images but you. I might not necessarily agree with you on that, but I will work through the pros and cons with you here to see if I can get you to think a little differently about this whole topic.

I'm a big advocate of working your images and understand that we all have a different definition of what an "edit" is. Don't get caught up in the definition of what an edit is. Suffice it to say, it's different for all of us and that's okay.

As a business person, you have to think about where your time is best spent. *You're* the most valuable and scarce resource your business has. That being said, I can't stress the importance of this rarely realized or underappreciated fact. Sure, you can spend 10 minutes perfecting every single image from a job only to hand over a DVD to the client, or worse yet, post the images online for them to view, but when all those minutes add up how much more revenue will have been generated for your business? How many more shoots could you have done—a task, by the way, that will actually generate revenue? How much more time could you have had to be with your family? The list goes on and on.

But I'd be a hypocrite if I didn't talk about my own journey on this very subject.

When I first started out, I did all my editing. It seemed to make sense. First, I thoroughly enjoy editing. Second, I was the one on the shoot and I know my client and what they'll like. Third, I know my style of editing—my brand, so to speak.

This approach worked in the beginning. It was great. I'd lie in bed editing until 2 a.m. I'd miss family events to ensure I was editing and keeping the business growing. See, my goal was to ensure a two-week turnaround time for all images. The one thing most photographers are notorious for is horrible turnaround time for their client's images. We've heard horror story after horror story about clients not seeing their images for months on end. I didn't want to be that guy.

It was good for a while. There are definitely benefits to processing your own work:

▸ You control the look and feel.

▸ You own the selection process.

▸ You know your client and their tastes.

▸ You can control the hard costs since you're the one editing.

However, as my business grew, the downside quickly reared its ugly head:

▸ You own everything.

▸ You're now the bottleneck.

▸ You're a limited resource.

▸ You're neglecting other aspects of your business to do this low-level task.

▸ You're neglecting work/life balance.

Here was the realization for me. I was sitting there editing in the month of October about four years ago. We had photographed about 10 weddings that month. I was trying to keep my head above water and still deliver on the two-week turnaround time. The average wedding takes about 10–12 hours for me to process. That's everything—culling, white balance, special edits, and so forth. Do the math on that. That's about 120 hours of editing. If I sat at my computer and didn't move to take a bathroom break and had food fed to me at my desk, that's three straight 40-hour workweeks of editing! *Not gonna happen!* That's the moment I knew I needed to find a solution. I could either hire an editor and train them, or I could outsource. Something had to change and fast.

Here was my thought process—and by the way, all I can advise you on is to be sure you go through your own thought process. Actually think about it. Give it the time and energy it needs and don't just write off outsourcing as something that's not for you.

My first thought was that I should hire someone. Initially, this made perfect sense. I could own the process, control what they were working on, control the look and feel. And then I started asking some basic questions and having a few realizations:

▸ How would this person scale? What happens the next time I have 10 weddings plus seniors in a month? There's no way a single person could handle that workload.

▸ What happens when they call in sick?

▸ What happens when they quit and go work for a competitor? How long will it take me to find and train a new person? What will I do in the interim? Post-production doesn't take a vacation.

▸ And finally, I have to pay this person year-round no matter how busy or slow we are. Payroll taxes, health insurance, and the list goes on and on.

These are all reasonable concerns. This quickly led me to the realization that I needed to seriously look at outsourcing.

Outsourcing immediately addressed several major issues:

▸ Scalability. Not my problem. The outsourcing company would have to be able to add and remove editors as my business grew. I would have to ensure that whatever company I chose to partner with had the ability to scale with my business. If I have a 10-wedding month, each of those weddings will come back to me in two weeks or less. If I shoot 20 seniors in a week, those too would all come back in two weeks or less.

▸ Call in sick? Quit? No problem. This is still part of scalability. This all becomes transparent to my business. This is something the outsourcing company deals with on a daily basis. They've built their business on the ability to handle this ebb and flow.

▸ Yearly wages? There are none. This was what sealed the deal for me. I only pay for the jobs they complete. I don't have to worry about an employee not being productive or playing on the Internet all day. The cost is on a per-job basis. So, when December rolls around and I'm not busy, I don't have to pay anyone.

Now, I know the objection you're about to have. I've heard them all too often. "But if you outsource it, how do you ensure that the images match your brand, your style, your *fill in the blank*?"

These are professional editors. They know what they're doing. There's nothing magical about color correction or selecting images. *Anyone* can do it. What is 10 hours of your time worth? Hell, 5 hours of your time? I'd rather be out shooting and making more money.

Any outsourcing company that knows what it's doing will be able to figure this out. Here's the kicker: Who cares if they aren't perfect? I'd rather them be 90 percent of the way there. That frees up my time significantly to focus on the business and on more shooting. Then when the images come back it's easy. I scan them to make sure they didn't miss anything. If they did, I just add it back into the selection. Instead of spending hours, I'm spending minutes on a job. And after each job, I give my editor feedback to ensure they get closer and closer to my style. And eventually we get in sync and it's like having my own editor without all the downside. And even as they have

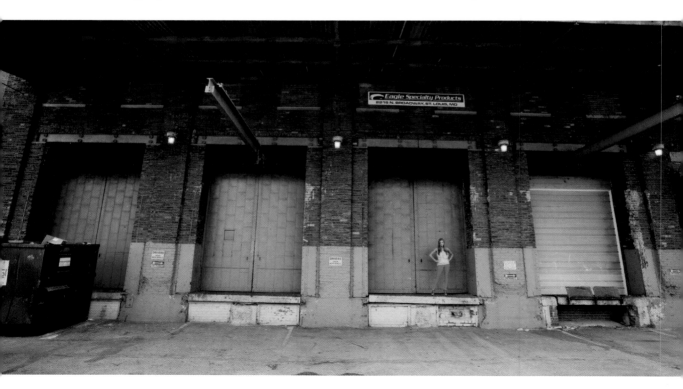

to scale, because they know my style and keep notes—the other editors are right on the mark.

If you've never tried outsourcing, I suggest giving it a try. It's truly one of the most liberating things I've ever done for my personal life and my business.

Here's what ended up happening once I decided to let go. I had more time to spend on the business. I spent more time marketing and advertising. I had more time to devote to shooting. So, my calendar opened up and we booked more shoots, thus generating more revenue for the studio. I can honestly say that my studio would not be where it is today had I not let go of the post-production. Yes, I know how this all started, with me saying I do love editing. However, I love a lot of things. Editing was a giant time suck and it was robbing me and my business of valuable time.

Yes, there's cost tied to outsourcing. But one-quarter of the sale from a shooting session will more than cover the cost of outsourcing. So, if I add one extra shoot with that time I now have, it's more than worth it.

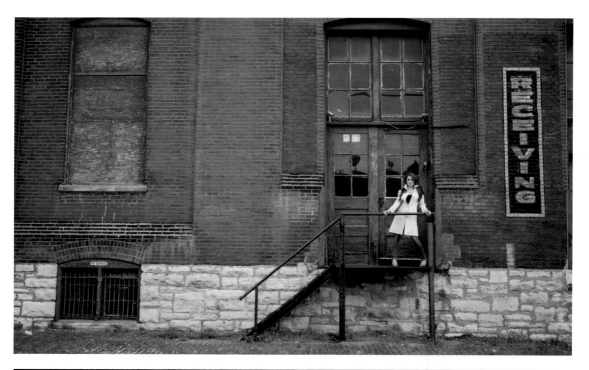

RAW vs. JPEG

There have been volumes of material written on this subject. Personally, if you're shooting JPEG at this point, I'm just wondering: With all the surmounting evidence for RAW, why are you resisting? It's banging you over the head and you just won't let go. RAW is better. There's no scenario in which it's not. Okay, I lied. There is one. It takes up more storage space. For crying out loud, storage space is pennies on the dollar...go buy more hard drives. You can get a 3 TB hard drive for less than $100.

I don't want to rehash this debate, but I do want to focus on some of the benefits of shooting RAW when it comes to post-production. These are the main things, in English, that mattered to me when I converted over.

Highlights/Shadow Detail

When you're a run-and-gun shooter like I am, exposure isn't always going to be perfect. Sure, I might be off by a half stop, but with RAW files, this is easily recoverable without destroying the file. This isn't the case when the file is in the JPEG format. I'll explain more in a second. The same holds true for shadow details. On a JPEG, recovering shadow details isn't possible. The image will fall apart, become pixelated, and just look like overall garbage.

In general, programs like Adobe Photoshop Lightroom can recover between one and two stops of highlight or shadow detail depending on your camera, file size, and other factors. The point is, RAW files are able to recover dynamic range data in ways that JPEG just cannot.

White Balance

Sure, in an ideal world, it'd be great if we got white balance right in camera. And your shoot would come to a grinding halt. For me, I'm moving too fast with changing conditions to sit there and mess with it every time I move.

RAW files don't convert white balance data. Therefore, once you're in your editing program, you can set this any way you see fit without impacting the integrity of your file.

Try this with a JPEG file and you'll soon realize you're in trouble. Skin tones suffer the worst.

More Data

More data is always better. RAW files are larger and that's because there's more pixel data. More dynamic range. This is important data. You don't want to lose this data. It allows for you to make editing decisions with contrast, color, and so forth once you're sitting down at your computer. With JPEG files your camera is creating the JPEG file on the fly. You realize that this means that your camera is editing your picture for you? That leads me to my next point—processing power.

Processing Power

Your camera doesn't shoot JPEG files. It has to create them. Your camera captures in a proprietary format and then has to convert to a JPEG file. When it does this conversion, it makes way too many decisions about your image file for you.

You're entrusting the look of your final image to a camera—dynamic range, color, and temperature. I'd much rather sit down at my way-too-expensive computer and make those decisions using the right tools for the job. It's kinda like those people who take pictures with their iPads. *Why?* Well, that may remain one of life's mysteries.

By doing post-production on your computer rather than your camera, you ensure that you're maximizing your images' potential and giving you and your clients as many options as possible when it comes to the quality of your post-production.

I hope this chapter has given you food for thought when it comes to the post-production process and the possibility of outsourcing. Push your imagery and use all the tools available to you. Special thanks to EvolveEdits.com, who takes my images to a level not possible out of camera.

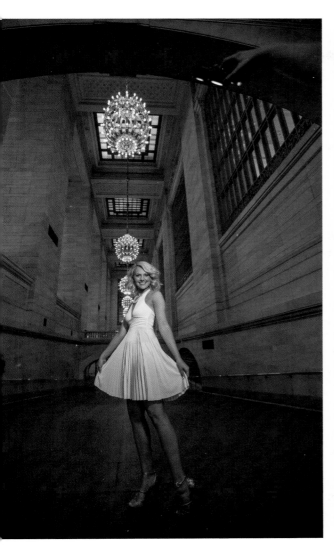
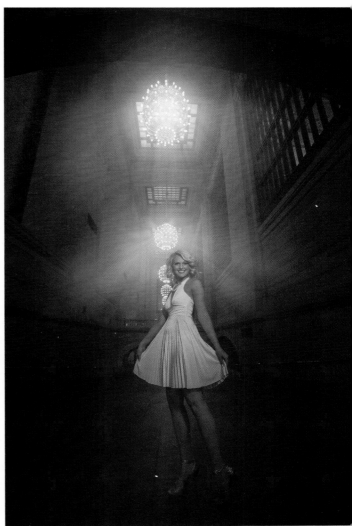

five

The Ambassador Program

NOTHING IS MORE powerful than peer-to-peer marketing. It's an immediate vote of confidence. It lets potential clients know you're worth the investment—not because you say so, but because their peers say so. Don't underestimate the power and value of this form of marketing.

Your ambassador program can make or break your studio. And although it's not a silver bullet, it's a critical part of a multiprong approach to your senior marketing plan.

What Is It?

The ambassador program is your way into the teen demographic. Sure, traditional marketing has its place, but the ambassador program can take your business to the next level.

Your high school senior clients become your sales and marketing team. You must have this program in place to have the level of success you're hoping for in your studio.

Today's teen is a very discerning consumer; the same is true of every generation. Not to mention, marketers see this as an extremely powerful and elusive demographic. Teens control the purse strings. They vote with their dollars. Sure, parents ultimately foot the bill, but the teens are the controlling interest here.

Having an ambassador program allows you to show off your work to your potential client base and do it in a low-pressure way. Your ambassadors are tasked with spreading the good word. In essence, they are your evangelists. Every business has them—clients who are so passionate about their products that they gladly tell the world about them.

There's no difference here. You're merely fostering the program to ensure you have some control over the message. Once your ambassadors are among their friends, you're hoping that they're talking about the experience. You don't want them trying to sell your product in the traditional sense. You want your ambassadors to spread the word, create awareness, and tell everyone about the great time they had in your studio. If they can do that, the rest is easy. When it comes to your ambassador program, think *brand awareness*.

In my opinion, if my ambassadors can create awareness that our studio exists, the rest is easy. Now you might be thinking, "Sal, isn't your studio already established?" Yes, we're very established, but the reality is, every year there's a new crop of seniors, so every year we have to start over, in a sense, and reeducate people. Maybe not from square one, but it'd be foolish for me

to think that today's freshman will know who we are four years from now without any additional branding, marketing, and promotion.

This is a yearly exercise, not a one-time event.

Finding Ambassadors

The next logical question: Where do you get started? Well, unfortunately, this is no easy task. Getting started can be kind of tricky. No one knows who you are in the beginning, and they're a little hesitant to represent your studio. No one wants to be a used car salesman. People want to represent well-established brands. It carries a sense of elite-ness with it.

The first thing to understand is that potential ambassadors are literally everywhere. And best of all, every year, a new crop of willing and able representatives emerges. You have to keep at it and be diligent with your efforts.

I'll never forget our first year doing this program. It was nearly disastrous. No one knew who we were and no one seemed to care. We offered free prints and free sessions, and yet we got no response. It was one of those crazy things where you're willing to do anything to get exposure, but no one wants it because they don't know you. And, of course, once they know you, everyone wants it. Chicken and egg, for sure.

I'll introduce two strategies for getting ambassadors: one is intended for a new studio just starting out, and the other for an established studio. Keep in mind, "new" and "established" are relative—not in shooting experience, but as it pertains to the high school senior market. So, you can have 20 years of shooting experience with weddings, but if you're new to seniors, you're starting at damn near zero.

Should ambassadors be girls or boys? You can select either or both. In my opinion, girls make better ambassadors. If for no other reason, they love having their pictures taken and love sharing them with friends. Boys, on the other hand, are usually less than enthusiastic about pictures, bring limited wardrobe, and rarely will go talk to their friends about it because of fear of being made fun of. Peer pressure can be an amazing influencer and, in this case, not to your advantage. However, give each a try and come to your own conclusions.

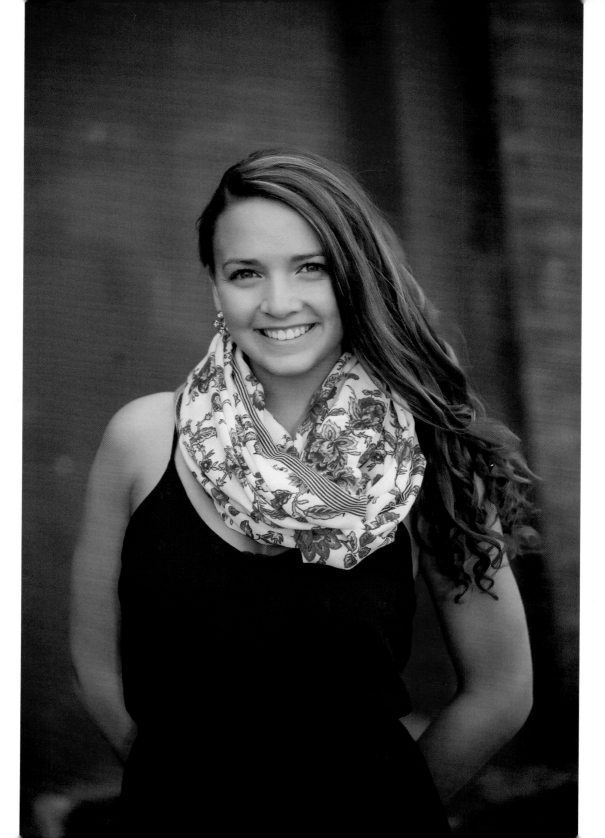

In the Beginning

In the beginning, no one knows you. No one cares about what you're offering. That's okay. You have one hand tied behind your back, but you can make it work!

Our studio started by doing two things. First, we ran an ad in the school newspaper. Most high schools have a school paper. Some are digital and some are still print. Either way, this is a direct line into the schools. Your first ad should promote the fact that you're looking for ambassadors. Keep in mind that some parts of the country or world have no idea what this means. So be sure to select your language carefully. For example, are they "senior reps," "senior models," "ambassadors," or some cleverly crafted new term you come up with? I don't care what you call them. The role is the same; they represent your studio in the school.

Back to the ad. In this ad, highlight what you're looking for in terms of a rep and some indication of what you're offering.

For example, "Class of 2015, we want you! Do you have what it takes to be a senior rep? Want free senior pictures? Check out www.xyz.com to find out more. Limited to two students."

Something to that effect. Now, that being said, you'll need to include a bad-ass picture. "If I'm just starting out, how do I get that picture, Sal?" Trust me, I understand.

You have to be resourceful. I'm sure you know someone at work or at your fitness club who has a teenager. Offer that teen a free photo shoot. However, let them know you're working on your portfolio and you'll need to use those images for your website and marketing material. You'll definitely require them to sign a model release. I suggest paying that individual $100 for 3–5 hours, or just offer them free images, digital or print. Either way, it doesn't matter. Offer them whatever they see as valuable. Be flexible here; you're just getting started.

Although this isn't a chapter on shooting, I can tell you this: Shoot in the way that represents your style and your brand. Don't do indoor studio work if you're trying to sell on-location portraits. You want to attract the right clients. Be sure to find your style and use those images in your marketing efforts. You'll thank me in the long run.

Phase 2 of this beginning work is to use direct mail. That's right, good old-fashioned direct mail. It still works. Craft a direct mail piece highlighting that you're looking for senior reps, similar in nature to your school paper ad. Companies like InfoUSA (www.infousa.com) and ASL Marketing (asl-marketing.com) offer lists of high school seniors in your area.

On average, we like to mail to about 1500 names. Our first-ever mailer led us to about 3–4 ambassadors. It's not guaranteed success, but this approach will get your name out there.

For direct mail, I suggest a 9x6 card. It's a larger size, but it will draw attention in the mailbox. You have one mission with this first mailer—get senior ambassadors. No matter what, this flyer will get your name out there and start creating some brand awareness, and that's always a good thing. However, this mailer's intention is not to try to start booking sessions. The timing on this is too early. You'll typically run ads and mailers looking for ambassadors in the November timeframe in the junior year of the students you're targeting to become ambassadors. For example, you aren't going after the current senior year; you're targeting juniors.

These two efforts combined should get you started with ambassadors. Your goal should be to get as many leads as possible, and that steers us into our next section—the interview. Make no mistake, not everyone can be an ambassador. You have to create a sense of exclusivity.

Once Established

Once you have established your studio, you have a little bit of an advantage in the sense that people know about you now. That doesn't mean you rest on your hard work from the previous year. It means your studio is on its way to becoming a household name in the world of senior pictures. This is a very important milestone for your business. Everything I wrote above still applies. You will still follow the same marketing path with one added benefit. Your ambassadors from the previous year will be required to refer you five potential new ambassadors from the junior class. I talk more about this below.

It is this combination of marketing and a built-in referral network that will launch your studio to the next level when it comes to generating leads.

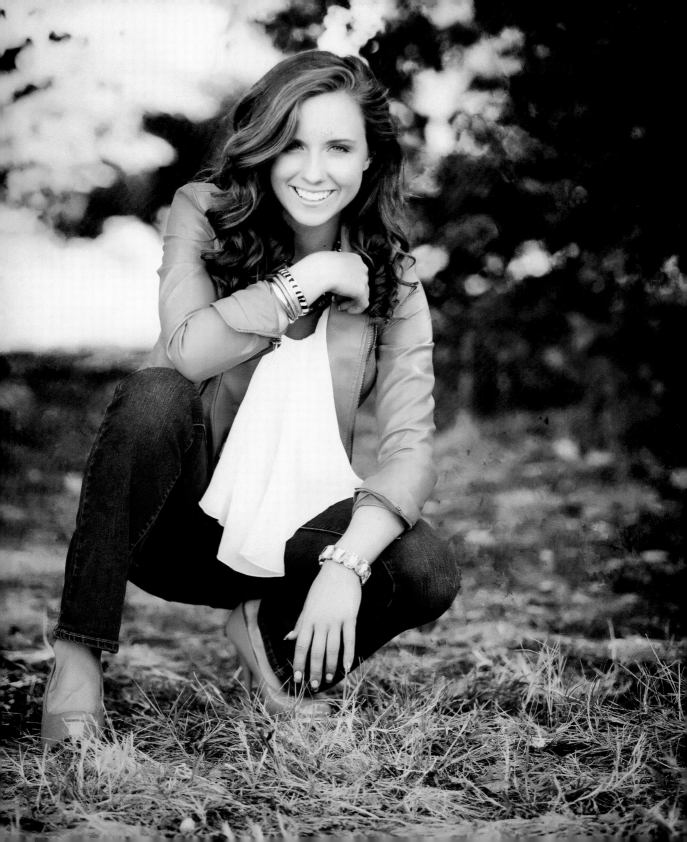

The Interview Process

Now, you should be ready for this. Maybe you're freaking out because you were horrible on job interviews yourself, but this is a big deal. This has to happen for you and for them. It forces them to take your ambassador program seriously. Not everyone—I repeat, not everyone—can be an ambassador. Stop with the trophy-generation mentality. There has to be a selective process going on for all involved. It creates massive buzz for your brand and ensures all involved are going to take this seriously. If they're just looking for free products or discounts, they won't want to go through this interview process and invest the time. So, the interview process is the first way to filter out some of these kids.

To start with, we create a form and ask everyone to fill it out before the interview. Don't overcomplicate the form. Keep it to a single page and ask relevant questions. Think of it as a get-to-know-you form. We use the interview form for talking points with the seniors when they come in for the interview. Ask questions like "What are your hobbies? Where do you want to go to college? What do you plan to major in? What charities, if any, do you work with? What sports do you play?"

In general, the interview should take no longer than 15–30 minutes. Again, it isn't meant as a way to grill the kids and see how they perform under pressure. My ultimate goal is to get to know them and see if they're able to represent the brand.

We have them fill out the form and bring it with them to the interview. In addition—and this is really important—have them bring a picture of themselves to include with the form. We do this for two reasons. First, it shows how they photograph, and second, it serves as a reference for when you go back and try to remember who was who. Last year, we interviewed nearly 30 kids for 12 spots. For the life of me I couldn't remember who was who without those pictures. They really help you remember. Another trick I use: Once the interview is over, I put a star on the application if I like them. If I don't think they'll work out, no star. Sorry, not everyone gets a star.

Let's talk a little about the actual interview. Keep it casual. Don't grill them. They should be doing more talking than you. After all, they came to tell you why they should represent your studio. Keep in mind that students may be a little shy at first; that's to be expected. They have never met you and they know what's at stake here.

We encourage and request that a parent be there during the interview. See, I'm interviewing the parent as much as I am the teen. Think about how peer-to–peer marketing works. You select your ambassador. Let's call her Susie. She's in school talking you up to her friends. "You have to use Sal. Sal, Sal, Sal, Sal, Sal." Susie's friend Nicole goes home and tells her mom, "Mom, we have to use Sal." Mom naturally responds, "Who the hell is this Sal?" And then promptly calls Susie's mom. See, Susie's mom becomes an ambassador as well.

Start the interview off and break the ice by initially doing most of the talking. No corny jokes or trying to be funny. I find that most people who try to be funny aren't actually that funny. Just be you.

The way I start off almost every interview is by saying hello, welcoming them, and asking them, "Are you nervous?" Ninety-nine percent of the time they say, "Yes, a little." I respond, "Don't worry. This is not painful at all. I just want to get to know you." We sit down, I offer them water or a soft drink, and then I ask, "Tell me a little about yourself. Where do you want to go to college, what for, etc.?" The ice is quickly broken and they start to relax.

The kids will surprise you. Often they show up dressed to impress, and that's how it should be. When I have a kid show up who is disheveled, with no fashion sense, I immediately start asking myself if this is the teen for our studio. After all, this is pretty much a model casting call. Show me what you got!

Remember, use the interview sheet as talking points, and don't overfocus. For example, here's what I'm looking for and why I think it's important. These are not hard-and-fast rules.

▸ **Sports.** Kids involved in sports are more social and more competitive. They're more connected, and they're more likely to be able to spread the word. They want to win. They want to be your top ambassador.

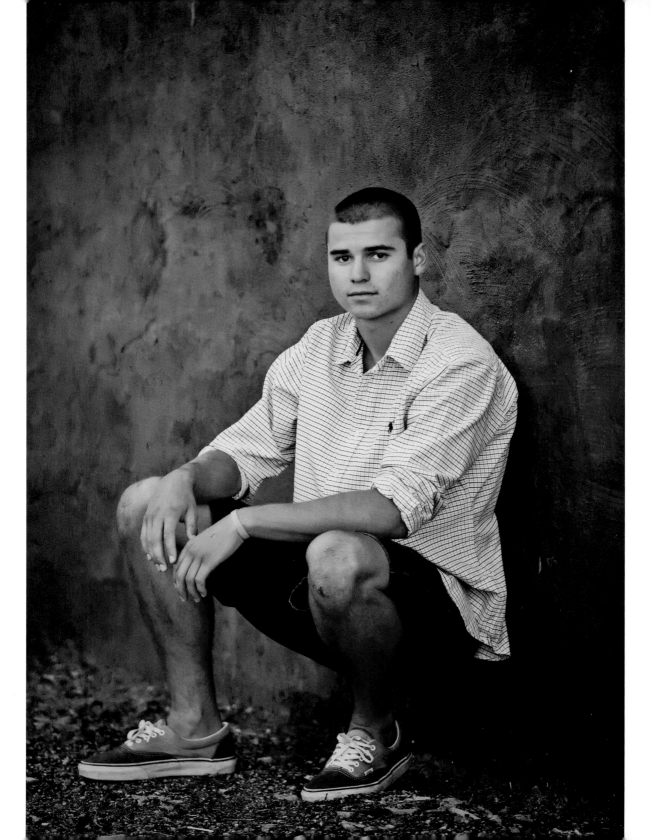

- **Dance.** Kids involved in dance know how to work their bodies and often do quite well in front of the camera. At heart, they're hams, and they love trying new and different poses and expressions.

- **Cheer.** Do I really need to expand on this? This is the clique I want to be in. If they say you're cool, then you're cool!

Use this as a guide. Find what works for you. Equestrians—or any unique sport or activity—will almost always lead to amazing pictures and portfolio building, so be on the lookout for some creative opportunities.

Here are some things that I tend to steer away from:

- **No social activities.** Kids who show up with nothing listed on the form are, unfortunately, just not going to be successful. Where's their social influence? It doesn't exist. Therefore, there's no way for them to refer anyone to our studio, or if they can it's going to be a major battle.

- **Shy.** Sorry to break the news to everyone here, but shy kids don't sell. They'll be destroyed by kids who are ambassadors for other studios. It's just reality. That's why it's so important to get these kids to come out of their shells during the interview. You have to make sure they can represent your brand. I've told a teen during the interview process, point blank, "You seem really shy and that concerns me. This is your opportunity for me to get to know you." You must be clear.

- **Overbearing parents.** Run. Run fast! They're on good behavior during the interview, or at least they should be. So, if they're already driving you nuts, it's only going to get worse over the next 10 months working with them. In our studio, the parents can absolutely ruin the teen's chances of getting the job.

Just last year I had a mom who wouldn't let her daughter answer a single question. She kept interrupting her. I finally said to the mom, "This is my chance to get to know your daughter. Please give her a chance to answer." Mom kept answering. Needless to say, her daughter didn't get selected.

Again, and I can't stress this enough, this is your opportunity to get to know these teens and ensure they can represent your studio. Beyond that, the only other advantages that these meetings yield are creative ideas based on activities the kids are into.

The Give/Get

Obviously, during the interview process, you'll have to explain how the program works. After all, what's in it for them? And more importantly, what do you expect from your ambassadors in order to declare mission accomplished? There should be total transparency in what defines success. This way, in six months everyone understands what happened and why.

Every studio is different, but this is how we run ours. Read this list carefully and tweak as needed. Our program is an adaptive one. We alter it slightly every year based on new trends and the studio's evolving needs.

Here's what we expect from an ambassador:

▸ **Class listing.** I need the names and address of every kid in their senior class. Sure, we can buy the list, but often it's inaccurate and incomplete. The kids are resourceful. Every year they have a way of finding that list or putting it together using the yearbook as a guide. The more complete and accurate this list, the better your direct mail will perform in that school. We like to do a combination of purchasing a list and combining it with their list of compiled names. Makes for a powerful mailing list.

▸ **Five referrals.** This is what it's all about. This is a direct measure of success. It can be tied to revenue. Let's be clear—a referral is an actual booking. Not a phone call or some potential future booking. Referral = session fee paid and scheduled. It doesn't matter where the referral comes from, either—it can be their school or a school in another country, for all I care. If they book and shoot in our studio, I get a sale out of it.

▸ **Additional referrals.** Any additional referrals receive a $25 studio credit. This is a great way to encourage your ambassadors to continue to refer people after they hit their five. We've had kids hit 18 referrals! That's a monster number for us, and we want to reward them for working so hard.

- **New ambassadors.** This might seem odd at first, but the best way to find next year's ambassadors is to look to your current ambassadors. After all, they know what the program is all about and are in a great position to refer teens who meet the criteria. We look for them to give us 3–5 names for potential ambassadors for the following year. This doesn't mean they'll all become ambassadors, but it's a start and a great jump on the next year.

Here's what our ambassadors can expect from us:

- **Free photo session.** Our session fees are $200–$300, depending on the type of session. We do this for free for our ambassadors. We make it an experience for them and go all over the city taking pictures.

- **Free hair and makeup.** As part of the experience, we bring in our hair and makeup people at our expense. This gets them looking amazing, and it ensures we have perfect images to use for marketing and advertising.

- **Free pictures.** Once they get their five referrals, they'll receive about $600 worth of free images. If they don't hit their five referrals, then no free pictures. Did you read that? Read it again. *No free pictures*. No. Not everyone can be a winner. I don't care how bad you feel. We make it clear from the initial interview that this is what we expect and here's what we'll deliver. If the ambassador doesn't deliver on their end, we won't be able to give them all the free pictures. Obviously, the shoot and makeup are over before they've had a chance to refer their five, but that's an investment I'm willing to make. When it comes to free pictures, keep in mind that you don't want to offer a large package; we only give our ambassadors prints that are 11x14 or smaller. The reason is simple—we still want them to purchase some pictures from the studio. If we give them large prints, canvas, and an album, they won't spend money in the studio, as there will be no need for them to do so.

> ▸ **Promotional cards.** We provide our ambassadors with rep cards to
> hand out to all their friends. This makes their job easier. We list some
> specials on the cards and give them about 100 of them to hand out in
> school, sports events, and so forth. If they need more, we'll absolutely
> print more for them.

This is a great program. Think about it: For getting out there and talking
up your studio and getting their friends to come, they get about $1000
worth of product and services—a very good deal. Additionally, they become
superstars in their school because you'll be using all their images in your
marketing and promotional activities.

Announcing Your Ambassadors

After the interview process is over—this should be around January on your
calendar—we announce our ambassadors for the upcoming senior year. The
kids are still juniors at this point. They'll shoot around March/April. This
ensures that you get everything you need and that you can start marketing
before the kids get out of school. Once school is out for the summer, it be-
comes almost impossible for peer-to-peer marketing to take hold.

To announce the ambassadors, we use Facebook. All the kids are plugged
in these days. It's a great way to get people talking and get the kids excited.
In addition, it starts them thinking about senior pictures. The rest of the
seniors will be photographed that summer before they go back to school.

How many should you select? Never has there been a more difficult question to answer. It depends. I am sure that's not the answer you were looking for, but it's true. Every year, we go back and forth on this. I base it on the kids, their circles of influence, the size of the graduating class, etc. At a minimum, I think you should have two, and I have gone up to as many as eight. Experiment and trust your instinct here.

What about the kids who didn't get selected? Obviously, you don't celebrate that on social media. Instead, send a personal email to each and every one of them thanking them for interviewing but reminding them that you had limited slots available. However, offer them a discount just for interviewing. We give them 75 percent off any session fee. My thought here is that they liked your studio and work enough to interview—why not make it easy for them to work with you?

Photographing Ambassadors

Unlike your other sessions throughout the year, this group gets some special attention. As I mentioned earlier, they'll be shot earlier—in the March/April timeframe depending on weather. In St. Louis, it can be 40 degrees one day and 75 degrees the next at this time of year. So, we play it by ear.

The session itself should be nothing short of amazing. Work with these students on wardrobe ideas and concepts. Now is the perfect time to expand

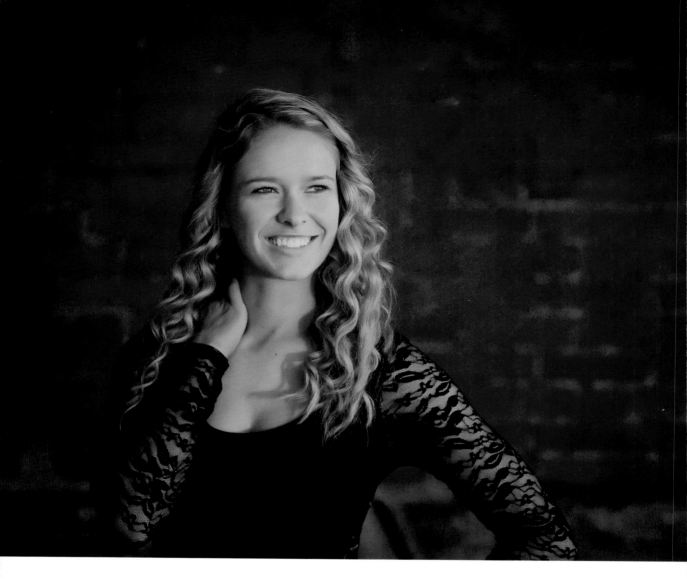

and improve your portfolio. I try all sorts of crazy things when I'm working with my ambassadors. It's my chance to reinvent my style a little every year. Dedicate half the day to working with the students. Find new locations, work on new lighting techniques, and take your time! Don't rush them; let them have fun. Remember, they're going to tell everyone about it.

Be on social media all day long for these shoots. Have someone with you using Facebook and Instagram all day. Create some hype and buzz!

Think about this: These shoots will define your entire year. They'll define the types of images you'll be creating along with the types of clients you'll attract. It's all right here in this moment. Give it the time and focus it deserves.

Make sure the family is along. It's not uncommon on my ambassador shoots for siblings to come back from college. Mom and Dad will be there. We've even had grandparents along with us. It's truly a family event. One time, we had both sets of divorced parents there along with their new spouses. Good times, I tell ya!

The key to success is to recruit your ambassadors early in the year, make the program fun and exciting, and push yourself and your creativity. If you do that, your ambassadors will love you and scream it from the rooftops.

Once their sessions are over, I typically rush their images and leak one or two teasers online. It gets people pumped and, of course, has a huge marketing impact.

Selling Ambassadors

Selling to ambassadors is a little different from selling to the rest of your clients. This is a group that gets free pictures, so convincing them to spend before they've had a chance to refer their five seniors can be a bit tricky. But if you follow our program, it's easier than you think.

Let's start right when the shoot is over. The parents naturally ask, "What's next?" (We'll talk in great detail about the sales process in Chapter 9.)

Send an email to each ambassador right after their shoot to schedule their preview. Strive to have their images ready in two weeks' time. That's key. You want them coming in excited and still pumped from the shoot. The longer you make them wait, the more frustrated they'll become. The shoot itself becomes old news.

In that very same email we include discounted pricing and packages regarding print specials. Now, there's no minimum order and nothing they have to buy, but we want to make it as compelling as possible for them to buy that day.

When they come in for the preview, they'll see their pictures as well as the various products we offer—just like a normal sales session. It's important to take your ambassadors through this process because you want them to be able to share with friends and family what the process looks and feels like.

Remember when we spoke about the give/get? And I told you not to give them anything large in the free prints? This is why. If these photos look great, Mom and Dad are going to want large portraits—it could be a head-shot or an architecturally based shot, but regardless they're going to want more than what you're giving them for free, which are all smaller prints. The biggest sellers to our ambassadors are albums and 16x24 headshots. This is what will drive the sale.

Something else to consider: The free pictures aren't delivered until they meet their minimum referrals. That could be June or July. No one wants to wait that long to show off their images. However, anything they order that day is delivered as soon as it arrives from the lab. This is another motivating factor during the sale.

The more compelling you make it for them to buy, the better your chances of getting a sale from your ambassadors. Don't think that just because they're getting free product and services from you that you can't get a decent sale out of it.

Next Steps ▶▶▶

Get out there and start looking for potential ambassadors. Find all the schools in your area. Reach out to friends and family and see if they have teenagers who would be interested in modeling for you. Build your portfolio and start experimenting with lighting techniques and different posing techniques. The first year is the toughest, but once you get this program rolling, it gets easier and easier with each year.

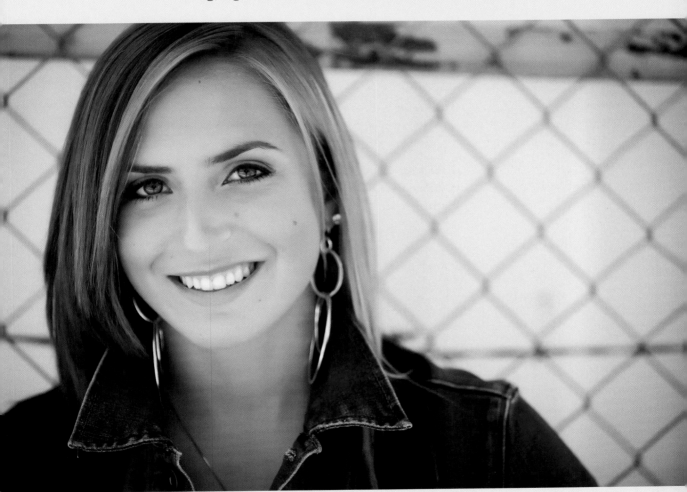

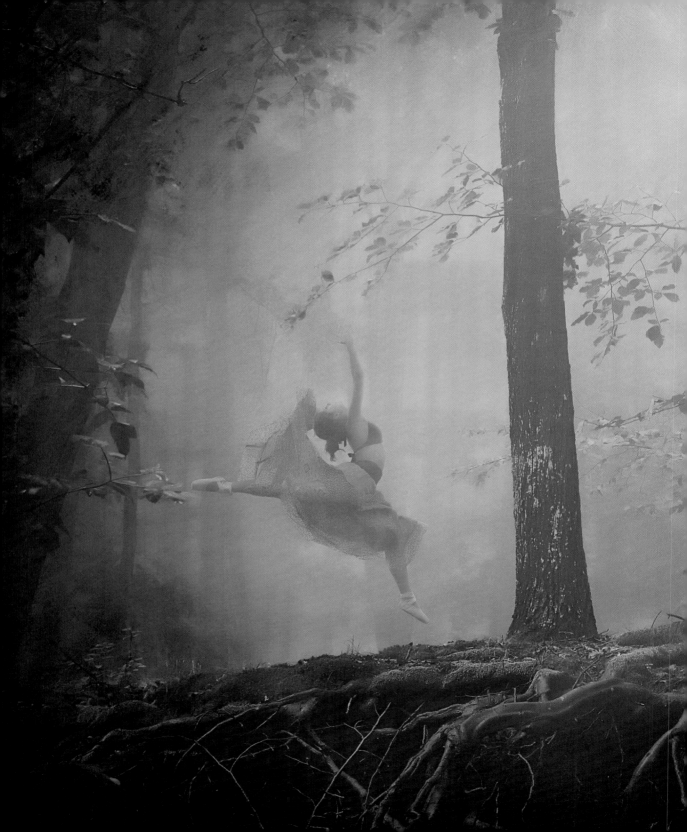

Marketing Your Business

THINK MARKETING YOUR business is all about telling your friends and family you are a photographer? Think again. Marketing to this demographic is one of the trickiest things you will ever do in your business. High school seniors' tastes and trends change daily. What was cool last week has been shot down as a fad the next. You have got to think outside the box with kids today. Most of the time they are smarter than they act, and they can see right through bogus marketing.

If you aren't good at marketing, hire someone or outsource it. Teens today are bombarded with marketing and advertising campaigns from some of the biggest brands in the world with multimillion dollar creative budgets. If you think you can just jump into Abode Photoshop or your word processor and come up with some clever script-y font and clip art and be successful, then sit down and grab a drink. We got some talking to do.

Understanding Teens

No, this is not an oxymoron. I'm sure every generation is the same. Though kids seem to have their own vocabulary, music, fashion, and different ways of expressing themselves, is it really any different than when we were kids? No, and I would guess this will hold true for the rest of time.

Once you accept that, it changes the way you view teens. I remember when I was a teen, regardless of how I expressed myself compared to today's teen, it all boiled down to the same thing: finding myself and what I was all about. It's one of the most challenging times of our lives. And the funny thing is, for most of us, it's one of the most nostalgic.

It's with this very basic information that I approach teens. I know they want to express themselves. The "how" of it all is semantics. My job is to foster and document it, not judge it. If you can do that, you're well on your way to understanding them. You will watch TV differently, listen to music differently, and see fashion differently.

If you're that person who repeatedly says, "When I was a kid...," you might want to find another type of portrait work to do.

Try to find what you have in common with them instead of focusing on the differences. Doing so will get them to relate to you, and ultimately your marketing and advertising will resonate with this group. That is, after all, what this chapter is all about—marketing and advertising. If you don't understand your demographic, how in the hell can you market to it? You can't. And many businesses have failed because of this seemingly trivial yet powerful common thread.

Teens want to be different. Teens want to be themselves. They want something unique. They want to be treated with respect and intelligence. That's

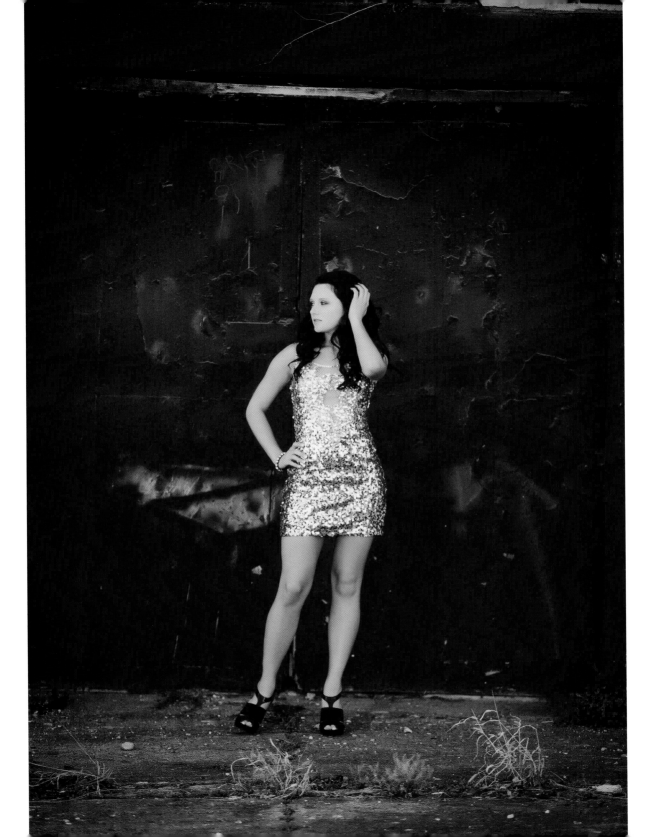

the one area I see the biggest backlash from teens today. Don't insult them with ignorant and sleazy marketing tactics. They'll reject your brand quicker than you can imagine. Also, don't push the same marketing on them that worked on their parents.

Easy, right? It's not that complicated. I'm just trying to give you some food for thought. Think differently about this group, and they'll respond to you.

The Brand

The brand is very powerful with this demographic. You better get it together. In general, I find photographers to be very bad at understanding branding. Everything you do is part of your brand—your car, your studio, your wardrobe, your website, *everything*. It's not just about the final image you show the client. It all plays into your brand. You need to understand this and get working on it.

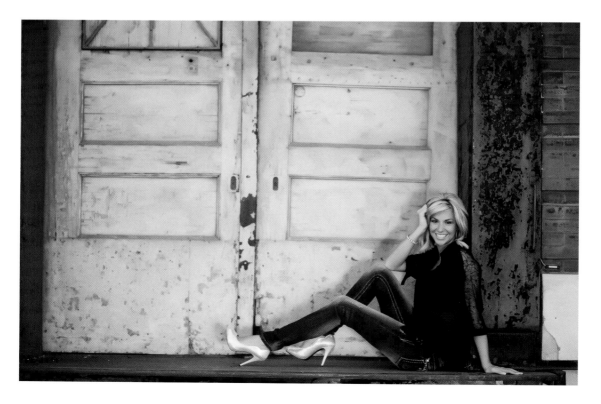

We could spend the entire book talking about branding and how to build your brand. However, the goal here is to get you to understand the importance of the brand when marketing to teens.

Whether you're a new or an existing studio, consider building a sub-brand that targets this demographic. Our studio has a separate Facebook page for seniors for that very reason. Our marketing and advertising is completely different as well. We use a bold, grungy look to go after the seniors versus a classy look for our weddings. Messaging is different, too. Seniors love the in-your-face marketing we use. For weddings, we use a much softer message.

Here's my advice: Your branding should be consistent from year to year, but simultaneously it has to evolve, if that makes any sense. The kids get bored quickly. Your messaging will be ignored if you don't adjust every year. It must have impact no matter what your brand is. Just saying, "Hey, we take pictures!" won't get your phone ringing. Think like the skeptical teen. Why should I use you? Will my coolness factor go up or down by having you take my pictures?

School Papers

Most schools have a school paper, albeit that is changing every day. Today a lot of schools are going digital. For you, it doesn't matter. Digital is better for showcasing your images. Most printed school papers have horrible print quality—maybe not all of them, but near our studio, I can tell you most of them are not pretty.

Cost

Rates can range from $100 to $1,000. Most are around $250. I recommend going either half or full page. Anything smaller is a complete waste of time and money. The newspaper is typically run by the yearbook staff; this fact becomes important when you're starting to work with the school, since you want to know and network with the key players.

While inexpensive, don't underestimate the reach the school paper can have. The kids love seeing their friends in the paper. If you run an ad, you better use kids from that school. There will be a sharing frenzy for everyone to see.

Timing

Depending on what you're advertising, adjust your schedule accordingly. Each school's deadlines and schedules are different, so be sure to check with the school. The important thing for you to consider is the time of year. Any time from mid-October through the end of the year, there's no point whatsoever advertising for sessions. The yearbook deadline is typically early October, so kids who waited that long to shoot have, for the most part, missed the boat.

However, that might be a great time to advertise looking for ambassadors for next year's seniors (see the previous chapter). When the spring comes, it probably makes more sense to advertise for summer photo sessions.

The key is understanding the school's schedule and adjusting your marketing plan.

Call for Models

Advertisements don't always have to generate revenue. Something I consider valuable is running ads for brand awareness. One way of doing that is to run an ad looking for models. Think about it. This approach accomplishes two things. First, it helps you build your portfolio, and second, it generates huge brand awareness about your studio in the schools.

The kids get super excited about this. They'll send in their Facebook and other social media pictures to apply. What better way is there to build your client list? You'll select the top model to shoot and build your portfolio. Hell, pick more than one. For everyone else who didn't make the cut, offer them 50 percent off a session fee.

Consider scheduling a call for models in the earlier part of the year. The latter part of the year should be reserved for marketing efforts to schedule shoots.

Ambassadors

If you're just starting out, getting ambassadors lined up is a big one. How do you get started? Well, we ran a half page ad looking for senior representatives.

We did this in the late fall looking for our first crop of ambassadors. We had some mixed results, but all in all it was a worthwhile ad campaign.

The ad should be fun and in-your-face to grab the students' attention. The copy could read something like, "Want free senior pictures? Think you got what it takes to be a senior model?" Of course you have to have the work to back that up. So, even if you have to borrow someone's teenager for the day to get your first shoot under your belt and that first set of images for this ad—do it!

Even once you're established, running ads for ambassadors is still a good thing. It gets people talking, which is what marketing and advertising is all about. You want your local community to be familiar with you and your brand. Then, when it's time to book a session, they know your name and your work.

Specials

From time to time, every business is going to run a special discount or promotion. The school papers offer a cost-effective way for that to happen. The school paper gives you access to the entire school. And don't underestimate the importance of cross promotions—just because you're doing direct mail or Facebook doesn't mean you ignore this as an option.

In the spring before school lets out, there's one special you'll obviously want to run: a discount on shooting sessions. This is paramount. I suggest offering these ads in March or April, promoting a huge sale. You may want to run back-to-back ads across multiple weeks or months to drive the point home and create awareness.

Consider running an ad for a 75 percent-off session fee or a one-day sale. We love doing this in our studio because it drives a strong call to action and gets people to engage. It's also a good idea to cross-promote to Facebook and to your direct mail to ensure you get the most traction.

What about a family session? You could run this ad later in the year around September when the kids first go back to school, offering 50 percent off a session fee or creating awareness of family portrait month—you know, October. Make it your own and tell the entire community about it.

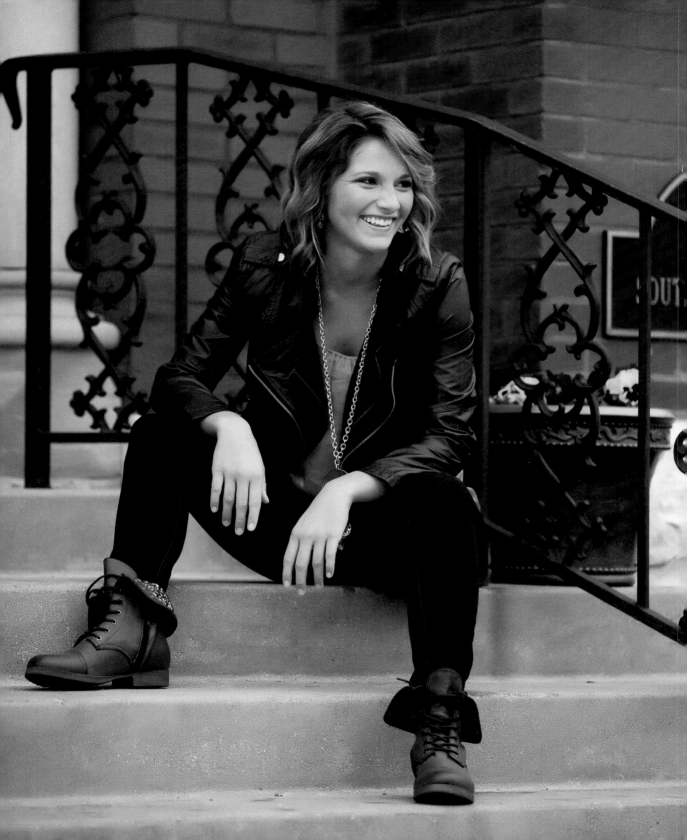

Direct Mail

No, direct mail is not dead. Everyone I talk to in the photography industry seems to act like direct mail doesn't work. Well, as an active user of direct mail, I can tell you it does work! Our studio uses it, and we've had great success with it.

Let's do a pro/con for direct mail. First, the pros:

▸ **Reach a large audience.** Think about it. You have a mailing list. Use it. Buy one. Use it. Put something in their mailbox. Everyone loves getting mail. I love getting mail. It's something that can be touched. It's tactile. You can mail to as many households as you like.

▸ **Ability to make an impact with a unique piece.** Select an unusual size to put in the mail. We like to use a 9x6 card. It's bigger than the average piece of mail. Sure, it's more expensive, but at the end of the day it stands out. The worst thing you can do is send a small card in an effort to save a few bucks. It will get lost with the rest of the mail and, more than likely, thrown out.

▸ **Control of messaging and who's viewing it.** Most mailing lists can be adjusted by household income, zip code, those who own versus rent, and other factors. You have complete control of your messaging and who is receiving the piece. In fact, you can adjust your mailer based on the part of town you are sending it to.

Now for the cons:

▸ **Expensive.** It costs about $0.90–$1 per card sent. So, a typical mailing will cost us about $1500–$2500. You can make it a little cheaper by selecting a smaller card and perhaps a lighter paper stock, but my philosophy is if you're going to do it, do it right. Also, and this is important, direct mail doesn't work if you take a once-and-done approach. You have to mail 3–6 times in order for the responses to start to kick in. I don't know why, but that's how it works. There's plenty of historical data to support this. I don't fight the numbers when it comes to stuff like this. I try to understand them and embrace a strategy that works. Direct mail works, but it's definitely an investment that you have to budget for.

▸ **Low conversion rate.** If you think you're going to send out a direct mail piece and immediately strike it rich, you'll be disappointed. It just doesn't work that way. In fact, when your recipients do respond, it will typically be a 2–5 percent response rate. And that's considered really good.

Direct mail isn't for everyone. You have to think long and hard about what your goals are for using direct mail. For our studio, I see it as part of a larger marketing strategy and a multiprong approach. This is your way of reaching the parents at home. You're mailing directly to the house and getting access to the key decision makers in most homes—the parents! I always want my name out there in the community. They have to see my work and know what I'm up to.

Remember that direct mail is an opportunity to stand out. These days, people are mostly bombarded by email. I know I hit the Delete key when I come across most specials that hit my inbox. We've become numb to email. Direct mail is something that's sitting on my counter when I get home at night. I flip through it, and if something grabs my attention I go online for more information. That's my goal with direct mail.

Rep Cards

Okay, so the parents are getting the direct mail pieces at home, but what about the kids? What are they handing out? How will they promote you inside the schools? This is where the rep cards come into play. They're customized to each school and for each rep you have. (And just a point of clarification here—your rep cards are used by your ambassadors. I know, we could have called them ambassador cards and made it easy, but after seven years of doing this, we still call them rep cards. Something else to consider—you don't have to use the term "ambassador" at all. I have seen studios call this role Senior Model and a host of other things. It's all up to you and how you want to brand things.) You want your senior reps handing out images of themselves—not some other kid from a year ago or from another school.

Admittedly, rep cards have a limited life span. Once school lets out, it will be all but impossible for your reps to hand these out. We like to have the cards ready no later than mid- to late April. This gives the reps ample time to hand them out in school to all their friends before school lets out.

Here's what we do, and it's very cost effective. We print rep cards on 5x7 photo paper and give each rep about 100 prints to hand out. It's easy to order more, and they can be ready in no time. In fact, if a senior needs more cards (a good thing!), we can print them online and have them ready via a one-hour photo lab at their local pharmacy or big-box store. And I don't care what anyone says—the print quality is just fine. They're using the same machines the big photo labs do.

So what should be on the rep card? Keep in mind that it's a smaller card and single-sided, so you have limited space. It isn't meant to be an editorial piece. It's all about the images, with a very simple call to action.

The one thing to consider—which you might already be thinking of—is that you'll want to formulate an overall strategy for your calendar. What I mean by this is that you need to plan the timing across all your marketing and advertising vehicles: Direct mail goes out on *this* date, and school papers on *that* date, and rep cards are handed out at *this* time of year, and Facebook gets your attention at *that* time, and so forth. Whatever you decide to do, coordinate your efforts across all your marketing.

On the rep cards, I like to advertise that one-day sale, which I discussed previously, in early May. It's a great way to fill your calendar. Sure, you're taking a hit on the session fee, but you'll more than make up for that with the print sales that will follow.

Another thing to consider with the rep cards is that you want to have a picture of the senior along with their name. You never want your studio to compete with the ambassadors. Here's a typical scenario: When someone calls, we ask how they heard about us. Well, if they received a direct mail

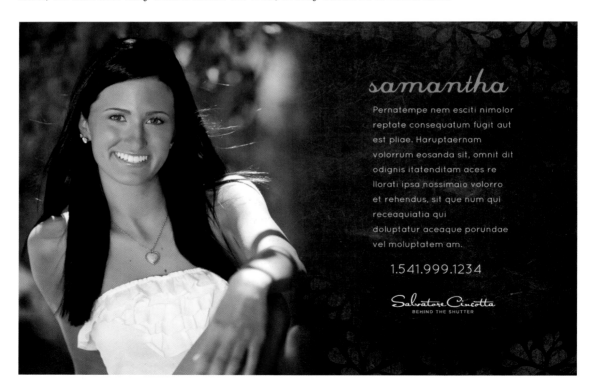

piece in the mail and then their son/daughter took a rep card home, who gets the credit for booking the session? The senior or the studio? We make it easy: Give it to the senior every time. The way we encourage this is to add a special incentive to the rep card. "Use this card and get a free sheet of wallet-sized images valued at $X."

It's a great way to get people to hang on to those rep cards. Who wants something *free*? Everyone does. This works! We've been doing it for over five years with solid results.

Social Media

As I write this part of the chapter, I think about what the future of social media might look like. Think back—not too long ago MySpace was king. It's almost comical. Facebook is king today, but will Google+ become the next heir to the throne?

At the end of the day, it just doesn't matter. You need a social media strategy for whatever is *hip, now,* and *today*. And just know that tomorrow it can—and probably will—all change. Don't sit on this and ever think you have it all figured out. As I'm writing this, I just saw that, without any notice, Facebook changed several things in their user interface. Oh. Cool. Thanks, Facebook.

So, with that being said, where to begin?

Facebook

The champ right now. You must have a presence. No if, ands, or buts about it. I've spoken to photographers who've said, "I'll never create a Facebook account." Okay. Good luck with that.

Teens are online. They're checking out their friends' pictures and making decisions about everything from dating to college to fashion. And trust me, they're making decisions about you.

It's not enough to just create a page. You have to *engage*. This is a very important term. Facebook isn't your blog where you post once every three months and call it a day. We post 3–5 times *per week* during shooting season. You have to get people looking at, talking about, and liking your work.

Building the fan base starts with content. When Facebook first started, it was a "Like" frenzy. People liked anything and everything. Today, people are a little more pessimistic—or at least selective—about the whole thing. You have to give them a reason to want to follow you. And in the world of photography, that reason comes in the form of pictures. People want to see pictures—and lots of them. No one cares about your cat or what you ate for breakfast. For the love of everything...my mother doesn't even care what I ate for breakfast, so why would I think my clients do?

Once you start building an audience, then you can promote to them via specials, casting calls, and so forth.

The best advice I can give you is simple: Set up your Facebook page ASAP. Be active. Be relevant.

Paid Social Media

Today, Google AdWords and Facebook ads give you access to a broad base of customers. You can target everything from specific interests to gender, from geography to keywords, and much more.

Each service has its own pros and cons, and the truth is that you have to try each on your own in order to realize if there will be any benefits. I wish I could endorse one over the other, but I'd be doing you a disservice. Instead, let me give you some guidelines to consider.

It probably goes without saying, but Facebook allows you to hone in on people using Facebook, and Google AdWords allows you to target keyword searches using Google. So, these services aren't mutually exclusive—it's not one or the other with Facebook and Google AdWords; you can do both. They're targeting two different systems. You can run ads on both systems at the same time and see which gives a greater impact.

Here's what I like about Facebook ads: I can run multiple ads at the same time with different metrics, different images, and different copy to see which generates more clicks. You can limit the amount you spend every day by setting a budget. To start with, try $15 per day. It's a small amount of money, and if it generates one booking, it's obviously worth it.

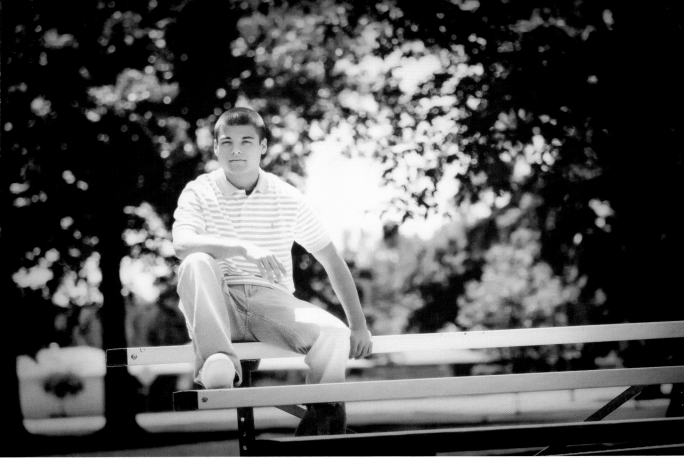

With Google AdWords, I like the fact that you can immediately jump to the top of your search rankings for any combination of keywords you're looking for. Ultimately, you'll be driving traffic back to your site. So, if you're struggling with search engine optimization (SEO), this is a great jumpstart and will immediately put you at the top of the list. It will cost you money—that's the difference. And just as with Facebook, there are all sorts of payment options and budget settings to meet your needs.

Your best bet is to log in and start playing around with these services and give them both a try. Our studio uses them at various times throughout the year to get some different exposure and more brand awareness.

Are you noticing a trend yet? You want your name to be everywhere and to be synonymous with high school senior photography.

SEO

Search engine optimization. I know. You just ran to hide in the closet. You want nothing to do with this. It's all Greek to you. I promise; it's not as hard as you think, but it does require some thought and planning. Entire books are dedicated to SEO and social media in general. How SEO works is evolving every single day.

In a nutshell, SEO allows your site and business to be found when someone searches online using keywords like "high school senior photographer." You have to work on this for your site. It's free advertising for your business. The only thing it will cost is your time.

There are many plug-ins on the market that help you optimize your site. We use a plug-in called Yoast. It's a great tool, and best of all it's free. Research SEO plug-ins, and the company that has invested the most on Google AdWords and optimizing their site will come up first. See how that works?

Seriously, though, you want your site to come back on the first page of search results. Do this exercise: Google your keywords now. Example: "High school senior photographer in New Orleans, LA." Where does your site come back in the results list? Anything beyond the second page is a joke. Sorry, but it's true. No one will ever find you. You have to be on the first page in your local market. That's the key. Again, it's hard work, but it's a worthwhile investment considering the payoff.

Posing and Lighting

Yep. Posing and lighting are part of marketing your business. Want people to talk about your business and spread the word? Define your style using posing and lighting techniques. Find consistency in your work. If I visit your site, will I see one picture on the obligatory fake background with the rose in color and the subject in black and white? If so, what does that say about your business and your brand? What kind of exposure will that get your business?

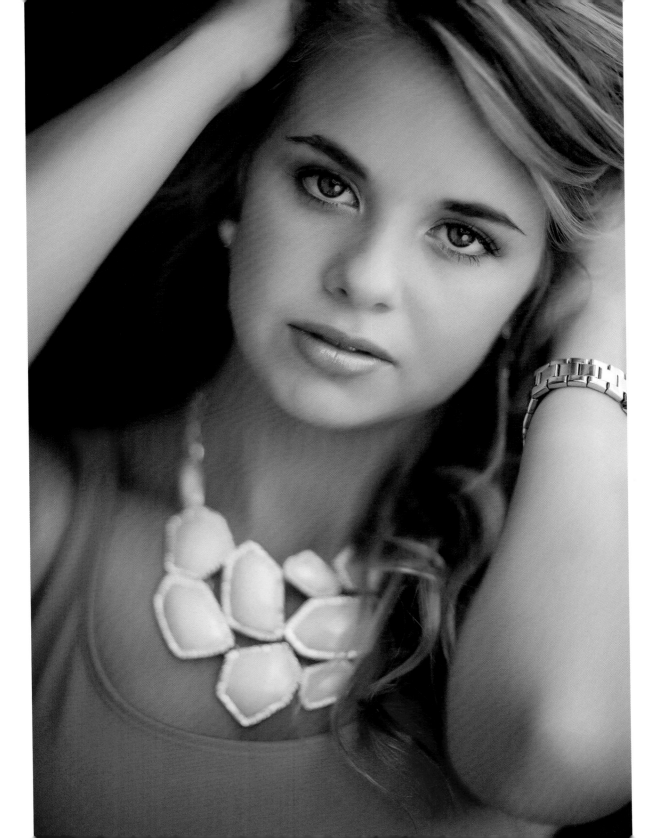

You have to get your audience to react with *"Wow!"* and the only way to do that is through great imagery. You have to master your craft. Don't misunderstand how business works. You can be the savviest businessperson out there, but if you don't focus on the art side of things you'll never find success.

The biggest challenge I see for photographers regarding their craft is not knowing who they are as an artist. You can't be everything to everyone. You have to be true to yourself. Take a stand! Establish your look and feel, and your clients will find you. They'll be motivated and inspired by your work. They'll be the best kinds of clients because your brand and vision are clear, and your clients have found a great match in you. When you're trying to be everything to everyone, you become just another photographer; the messaging and marketing become convoluted and confusing to your clients.

You might be thinking, "How do I find my look, my voice, my brand? What if I don't know what it is?" The best place to start is to look to corporate America. Is there a company you look up to? A brand you love? A brand you want to emulate? This is where we started. And it is where we continue to look for inspiration. The ultimate goal is to be consistent with messaging, but what that messaging is will come over time through trial and error and getting to know your target client better and better.

Next Steps ▶▶▶

Marketing doesn't have to be complicated or intimidating. We're all afraid of what we don't know. The best advice I can offer you is to experiment. Try new things. Take a risk. Be different. Don't be safe. Safe doesn't win. When we market and advertise, we play to win. We want to innovate and be a leader in our market, not a follower.

Get on your social media presence immediately. (See Chapter 8 for much more on this.) If you're new, set your site up! If you're a veteran, make your social media matter. *Engage!* Start posting. Put it on your calendar—budget three hours per week and just go and do it! Stop making excuses. Sit, have a cup of coffee, and post some pictures.

When it comes to direct mail and rep cards, if you don't have time to design them, buy templates. There's nothing wrong with templates, especially if you're using them as a starting point. Using a template saves you time and lets you focus on other areas of your business.

For your mailing list, look to companies like InfoUSA (www.infousa.com) and ASL Marketing (www.aslmarketing.com) to get a list of seniors in your area. They will allow you to narrow your list by all sorts of demographical data.

It's there for you—the information, the resources, and the services you need to market and advertise your business. Now get moving, and make marketing a priority for your business. You need to become a household name.

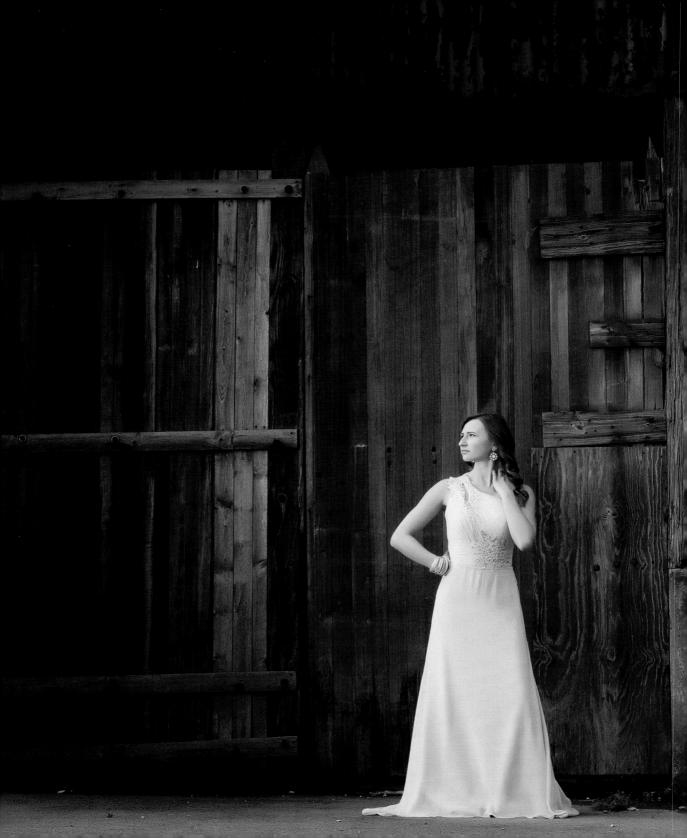

Costs and Pricing

UNDERSTANDING YOUR COSTS and determining appropriate pricing can make or break your business. There are no ifs, ands, or buts about it. I have run across very few photographers who understand this. They want to live in this everyone-loves-me world with no sales process and just hope and pray that people will pay for their work. No business in the world can survive with this business model. Do you know why? Because it's not actually a business model.

If you're looking to be a weekend warrior for the rest of your life, then I suppose you can ignore this chapter. However, if you want to make a profit, retire someday, go on vacation, and run a successful business, then pay attention.

This chapter combines some of the key concepts from my book *The Photographer's MBA: Everything You Need to Know for Your Photography Business* (Peachpit, 2012) and updates it specifically for high school senior photography.

The question every business struggles with is "What should I charge?" This is no easy question to answer. Obviously, it depends on several factors. My goal is to educate you on the things you need to consider before you put your pricing in place. Something to carefully consider and understand: Pricing is a living document. It is never set in stone. The reason this is so important is because you need to recognize that you have to adapt to changing market conditions, client demands, and ever-changing costs.

Understanding your costs will help you determine your price. Too many people jump into business without a full grasp of the basic concepts. In this chapter we'll drill into the business basics to get your costs under control and put a pricing structure in place to ensure you make a profit and earn a good living.

Costs

Costs. Sounds easy enough: This is how much I paid for something, right? *No!* That's not how it works. I love when I'm talking to people who got into this industry as a hobby, and they insist they are making $50 per hour. "What do you mean, Sal? I shot a wedding over the weekend for 10 hours. They paid me $500 and all I had to do was burn a DVD for them. So, my cost was like $1, right?" Good grief!

Trust me. It cost a hell of a lot more than the price of the DVD. This is where the rubber meets the road, so to speak, and you have to start thinking like a business person—not like an artist. You have bills to pay, and you need to consider the cost of new equipment, insurance, retirement, and a host of other bills that add to your cost of doing business.

If you're reading this and you're one of those weekend warriors, I might seem a little harsh. But I'm not harsh because I have ill will toward you as an enthusiast. I'm harsh because I have no tolerance for bad business. You're leaving money on the table. Money you can use to buy better equipment. Money you can use to send your kids to college. Money you can use for…fill in the blank here.

See, I am a huge believer in our industry and a huge believer in empowerment! I want to see everyone find their own success, but sometimes I see people get in their own way and hinder their ability to achieve success. And with that goal in mind, let's start talking about costs.

Now, I don't want to go all business school on you, so let's focus on the things that will matter at a higher level and the things that will allow you to take immediate action within your business.

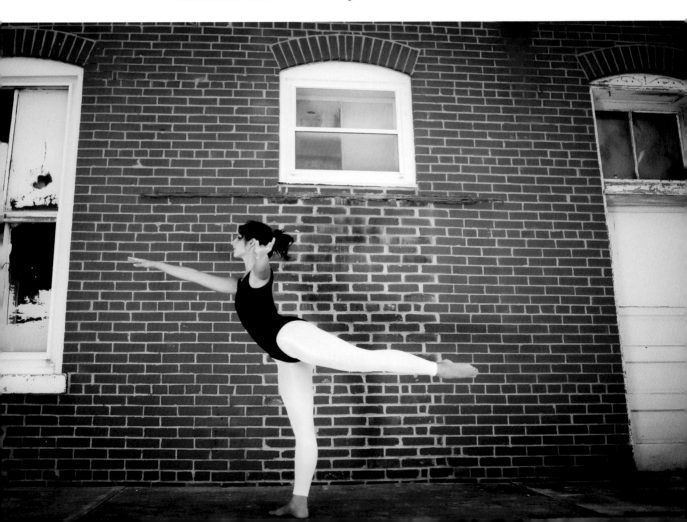

Cost of Goods Sold (COGS)

Often referred to as COGS, this number is important in your overall pricing strategy. One common mistake I've seen other photographers make is to price their work compared to what other photographers charge. Who cares what other photographers charge! Not a question. It's a statement. It just doesn't matter. You need to understand *your* costs and *your* clients before you can determine the price you're going to charge.

So, back to COGS.

The cost of goods sold is defined as something like this: "all costs of purchase, costs of conversion, and other costs incurred in bringing the inventories to their present location and condition. Costs of goods made by the business include material, labor, and allocated overhead."

English, please.

Okay. The costs for your business or products have to include the cost of everything that went into producing it along with some estimated costs for overhead. For example, the cost of an 8x10 print is not $2, the price you'd pay from a professional lab. To correctly determine the cost of that 8x10, we have to think about the following:

▸ Rent for our studio space (or home-based business)

▸ Electricity

▸ Shipping

▸ Gas

▸ Drive time to and from shoot

▸ Storage space for the digital images and their archives

▸ Insurance

▸ Administrative overhead like phone calls, packaging, inspection of the prints, customer service

▸ Equipment like computers, cameras, lenses, memory cards, flashes

▸ Continuing education

And the list goes on and on. I guarantee you one thing: This costs a lot more than $2. In fact, if you're charging less than about $25 for an 8x10, you're probably losing money on the deal.

Here's where I see a lot of photographers—and businesspeople in general—go wrong. They completely underestimate the cost of their business operations.

Although I know some of these costs seem insignificant, they add up quickly. These are costs that can't be ignored and have to be accounted for somewhere to ensure that you're successful in both the short and the long term.

What a lot of other kinds of businesses will do is come up with a magic formula given to them by the accounting team to account for some of those fixed and variable costs to apply to the actual costs of the products. This allows a fair gauge of what it's actually costing you. Of course, some of these numbers are a little magical. For example, let's take gas: You might drive 5 miles to one client and 20 miles to another. I don't expect you to sit there and calculate your actual costs every time you have a photo shoot. You'd be spending more time tracking your costs than you'd be shooting and making money.

The big thing to understand is that these are costs that can't be ignored. If I can get you to see that, we're heading in the right direction.

That being said, my formula for costing goes against the grain a little. Let me explain. I don't want to spend time trying to track my costs or time down to the minute, but I still need to be profitable. So I use a costing formula of 15 percent. Simply stated, if I can keep my cost of hard products at 15 percent or less, the rest will work itself out.

Now this is a rough number and you have to understand my sales process. We don't sell a la carte. We are a package-based studio. (Later, we'll talk more about why I don't believe in a la carte pricing or build-your-own packages.) The 15 percent figure doesn't hold true for individual prints. So, an 8x10 will cost you about $2. With the 15 percent number, you'd charge around $14 for an 8x10 (that's hard cost divided by 15 percent: $2 / 0.15). You would also go bankrupt.

I'm also not a fan of the pricing calculators that encourage you to add a markup of 300 percent (or any other variable). They don't work quite right either. Let's follow our 8x10 model: $2 cost x 300 percent markup. Now you're charging $6 for an 8x10. Oh boy. I can see you earning that starving-artist badge quickly.

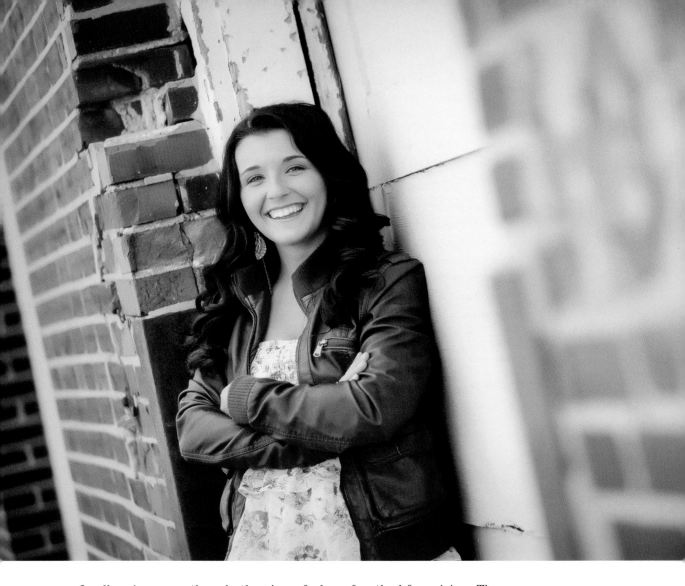

In all seriousness, though, there's no foolproof method for pricing. There are two lessons to be learned here. One, there's no silver bullet. You have to massage this process to fit your business and each product you offer. Two, a la carte pricing makes it difficult to achieve any sort of consistency. Instead, I believe in a bundled-pricing strategy. This gives you more control over your overall costs and profits. And frankly, your clients are already used to bundles. Everywhere they go, things are bundled for discounts. From the grocery store to Sam's Club, bundles are the way to go.

Pricing

No matter where I go or who I talk to, how to price your goods or services seems to be the biggest challenge for any photography studio. But pricing strategy doesn't have to be complicated; it just needs to follow some basic business principles. And now that you have a good idea of the cost of your products and services, you should be able to price for success.

First, let's explore a few questions out there. Should you offer a la carte pricing—basically allowing clients to build their own packages—should you offer a print credit system, or should you offer a bundled system? These are all reasonable questions you may have. The biggest problem of all: There are educators all over the country teaching different philosophies. Ultimately, you'll have to come to your own conclusion based on the type of business you're running and what you think will work best for you.

The Session Fee

For me, the session fee should be for just that: the cost of the actual session. The client is paying for your time and talent as an artist. Don't throw everything and the kitchen sink in there. You're devaluing your offering if you do that. If people want to work with a professional photographer, there's a cost associated with that.

The amount you charge is dependent on many factors, including your niche, your experience, and the current competitive landscape. No matter the kind of photography business you're pursuing, you need to calculate this fee.

Our studio charges about $300 for most portrait sessions. This includes a certain amount of time for the actual shoot. No prints or digital files are included in this fee. All those items are listed earlier and beyond the cost of my time. When we were starting out, we charged about $100 for a session. I think that's a great place to start. Having a fee for your time will ensure you get closer to working with the right clients—those who appreciate the value of your service.

In the spirit of talking about the value of a session fee, the next logical question should be "Would you ever waive your session fee?" Absolutely. As with

everything else in the world and your business, you need to look at this stuff on a case-by-case basis. When it makes sense, I will waive my fee knowing that there's a bigger sale and opportunity on the back end of the shoot.

Look within your industry to get a sense of how much photographers are charging for their services, but remember: This is just to get a sense of the market and should be used for reference only.

As it relates to seniors, here are some options for pricing your sessions. When we started out, we offered three levels of sessions (Option 1). Today, we only offer one price point (Option 2).

Option 1

▸ Session A, $100: In-studio only. 3 outfits. Up to 1 hour.

▸ Session B, $150: Outdoor local session. 3 outfits. Up to 1.5 hours.

▸ Session C, $200: Outdoor destination (this can be another city, their home, or just a cool location 20 minutes away). 5 outfits. Up to 3 hours.

As your studio grows, you can become a little more selective in what you are offering and the pricing you charge.

Option 2

▸ Session A: Gone. We no longer offer in-studio sessions. It just doesn't match our brand.

▸ Session B, $300: Outdoor local session. 5 outfits. Up to 2 hours.

▸ Session C, $300: Outdoor destination. 5 outfits. Up to 2 hours.

We are at a point with our studio where we don't want to offer a session for less than $300. This is because we place a higher value on our time. So, clients will select their session on where they want to go and shoot. The value of my time, however, doesn't change.

Regardless of what pricing you offer, give your clients options. And don't forget, you can run a sale on your sessions to make the price point more affordable depending on how your sessions are booking up. You can lower prices via a sale, but it's very difficult to raise them in the middle of the season.

Various Pricing Models

As I previously mentioned, I am a package/bundle guy. You'll see that I err on the side of bundled discounts in all my offerings, and I think our clients are used to this. It's basic consumer behavior—people want a deal. Let's explore each option.

A La Carte

The al a carte option allows your client to buy whatever they want and build their own custom packages. Sounds like a great idea at first. I mean, what's not to like? I can see the promotion behind it now: "We allow all our clients to build their own custom packages." However, after some implementation you might soon realize you're limiting your sales. Why, you might ask?

When a client is selecting and building their own packages, they're making pricing decisions—the worst kind of decisions for our type of work. They're adding things up in their head and seeing how much things are starting to cost. This will influence their behavior in the wrong way. Rather than selecting what they want, they end up selecting what they can afford. And the more they add to their shopping cart, the more those dollars add up. In my opinion, this sales model isn't conducive to consistently big sales, and I base it solely on my own behavior as a consumer. I would rather my clients make selections based on what they're saving versus what they're spending. This offers a huge psychological advantage to your business and your sales process.

A la carte pricing, as it relates to packages, is there for one reason and one reason only—to punish bad behavior. We want to dissuade our clients from making a la carte purchases. It's just not where we want them, mostly because our margins just outright suck. Think about this—depending on the products you decide to offer your clients, certain products have better margin than others. That's okay and that's normal. However, this is why packages are so important. You can bundle products together in a package to ensure that at a certain price point, you have the margins you need to remain profitable. And for us, that's the 15 percent COGS number.

On the next page you'll find our a la carte pricing. Remember, this is a living document and you should adjust it as your market conditions change. Also, this is where my pricing is today. Depending on where you are in your career, I would lower or raise prices by as much as 40 percent. At the end of the day, I can't stress this enough—the goal with this pricing is to dissuade clients. So, charge whatever you want to make that happen. If you find a lot of clients going with the a la carte pricing, then you're a la carte pricing isn't high enough. To give you perspective, four years ago we charged $25 for our gift prints. If you're in the northeast, I recommend charging $100 for gift prints.

What I want you to focus on is the structure of the pricing. Notice that as you jump from size to size in the wall portrait category, the price jump is $100. Think about how your clients are processing this. It just makes sense. As they jump from size to size, they understand it's $100, not some random number that has no rhyme or reason. Same for canvas. In addition, to go from a wall portrait to a canvas is a $300 jump. Again, it just makes sense to

the consumer and that's the most important thing to consider. To go from a 1.5-inch canvas to a 2.5-inch canvas, use 25 percent as the multiplier.

Gift Sizes

- 8 Wallets: $50
- 4x6: $50
- 5x7: $50
- 8x10: $50

Wall Portrait Sizes

- 11x16: $295
- 16x24: $395
- 20x20: $445
- 20x30: $495
- 30x30: $545
- 30x40: $595
- 15x30 Pano: $445
- 20x20 Cluster: $1499
- 30x30 Cluster: $1799

Canvas Portrait Sizes (1.5 in./2.5 in.)

- 16x24: $695
- 20x20: $745/$931
- 15x30: $745/$931
- 20x30: $795/$993
- 30x30: $845/$1056
- 30x40: $895/$1118
- 20x20 Cluster: $1999/$2299
- 30x30 Cluster: $2499/$2999

Credits

A credit-based system can work a number of ways, but the most common is likely to be along these lines: purchase this package or session fee for $X and get a $500 print credit for our studio.

No matter how you slice it, this is the worst model of them all. When you sell a client "credits," their mindset is in the wrong place. I know this, because we tried it.

No matter how they acquired the credits, the end result is the same. The client believes they don't need to spend any more money because, after all, they have all these amazing credits.

Again, it comes back to consumer behavior. Ask yourself this: When you have a $100 gift card to your favorite store, do you go in planning to spend $500? I know I don't. Which is not to say I won't spend more, but it's an up-hill battle to get me there. I don't want to arm wrestle with my clients to get them to spend more.

When we implemented this model, client after client would walk in thinking they didn't have to or, worse yet, didn't want to spend more money. Then we had to become heavy-handed with the sales tactics to get them to spend more, and that isn't who I want to be. I want to be able to look myself in the mirror every day and feel good about what I'm offering clients. I don't want to feel like I'm an infomercial host. Obviously, I'm not a fan of this model.

Packages

If you haven't already been able to figure it out, bundling is my favorite option. Why? At its core, everyone loves a deal! Bundling is everywhere we

look. *Everywhere!* From fast food to home purchases, there's a bundling of products or services that will, compared to buying things a la carte, save you money as a consumer.

From a seller's perspective, bundling helps you get larger sales averages because you are, to a certain extent, directing clients to larger bundles that offer them great savings and, hopefully, more profitability for you and your business.

So, let's come back to consumer behavior. Whereas a la carte pricing gets a client thinking about how much something will cost them because they see the number growing with every item that they add to their list, prepackaged bundles evoke a model of cost savings. Clients see that by buying into a bundle they are in fact saving 30, 40, 50 percent, or more. The psychology here is brilliant. Marketers all over the world employ this model with great success. Who am I to argue with them?

This model drives sales based on an approach of savings rather than spending. It's as simple as that, and it works. It works on me, works on you, works on consumers everywhere, because it makes sense.

Here is a peek at my high school senior packages.

Package A: $1999 ($3800 Value)

▸ 8x8 20-page metallic album

▸ 16x24 canvas

▸ 15x30 pano

▸ 12 gift sizes

▸ 15 sheets of wallets

▸ Signature book

▸ Images posted online for 30 days

▸ Facebook (ordered prints)

▸ DVD slideshow

Additional Discounts

▸ 40% off Signature Series line

▸ 25% off any additional wall portrait or canvas

▸ All additional gift sizes for $10

▸ 25% off any cluster

▸ Upgrade wallets to metallic for $99

Package B: $1199 ($2100 Value)

▸ 16x24

▸ 10 gift sizes

▸ 10 sheets of wallets

▸ Signature book

▸ DVD slideshow

▸ Images posted online for 14 days

▸ Facebook (ordered prints)

Additional Discounts

▸ 25% off Signature Series line

▸ 25% off any canvas, album or wall portrait

▸ Gift sizes for $25

▸ Upgrade wallets to metallic for $99

Package C: $799 ($1050 Value)

▸ 4 8x10

▸ 8 4x6 or 5x7

▸ 8 sheets of wallets

▸ Signature book

Additional Discounts

▸ Gift sizes for $35

▸ Upgrade wallets to metallic for $99

▸ 50% off DVD slideshow

In looking at my packages, I'm sure you have lots of questions, all of which I'd never be able to answer within the pages of this book. But I want you to focus on the structure of the packages and understand key concepts. This is the most important piece of the pricing puzzle. As I stated earlier, pricing is a living document, which means it should change and be somewhat volatile—but not unpredictable! Remember, you have to hit certain profit margins—you're trying to keep your package hard cost to about 15 percent of sales. At most, you can push that close to 20 percent, but that would only be for the top package because you're bringing in more sales dollars.

Here are factors to consider when looking at my packages and building your own:

▸ **Top-down approach.** List the most expensive package at the top. Back to psychology. It's easier for people to come down in price than go up in price.

- **Three packages.** Don't confuse your clients. Keep it simple.

- **Additional discounts.** This is important. You don't want them to get into a package and stop spending. Make it easy for them to keep spending.

- **Pull through.** Don't offer everything in your base package. Give them a reason to go to the next level of package. What is that thing, that thing that will pull them up into the next level of spending? You have to figure it out. In our packages we use larger sizes, canvas, albums, web galleries, slideshows, and Facebook as pull-through items.

- **Notice no digital files.** Only Facebook.

- **Notice no web galleries in the base package.** The only way these get posted online is if the client buys an online gallery or if they're in a package it comes in. Again, this is motivation to get them into an all-inclusive package.

- **Show the value next to the price.** This drives home the savings point. That number is derived from—you guessed it—the a la carte menu. So, the higher your a la carte pricing, the greater the perceived discount. The great news is, your profit margins don't change. For our studio, each one of those packages has a hard cost of 17 percent or less. That's huge!

The Psychology of Pricing

Here's what you should *not* do when trying to determine your pricing: Look to your competitors. This is one of the biggest mistakes I see photographers around the world make. We offer a unique, one-of-a-kind service; I don't care what Bob down the street offers or charges.

You have to value your brand. You have to value the service you provide. Playing copycat isn't going to help you find success. You have to find your own niche. And pricing is a big part of sending a message to clients on where you stand as a business.

Are you competing on price or are you competing on some other factor, such as service and quality products? There are certain industries in which competing on price is the way to go. The low-cost provider wins. This works

well for products that are commodity products and services. Commodity products and services are those products and services that have no discernible difference between them. Toilet paper is one of those products. Is your artwork the toilet paper of your local market? I sure hope not. I see my artwork as being extremely unique. And as a unique product offering, I can charge a premium for that. I won't compete on price.

Here's something I can guarantee you: If you compete on price you'll ultimately fail! You're a limited resource. You can only work so many events per day, edit so many pictures, take so many phone calls. Look to the corporate world for proof of this. Show me anywhere in the corporate world—any product, any service—where a limited resource is being sold for a discounted amount. Or where a company like that competes on price. It doesn't exist! You know why? Because it's a ridiculous way to run a business. So, if you're doing this, stop it now!

You're more than a weekend warrior. You're more than just a DVD of images. You're more than just a guy/gal with a camera. You're an artist! People will pay you for your vision of the world. This is a gift. Value that gift and you'll have the confidence to charge what you're worth. Like anything in life, your product or service is worth whatever someone is willing to pay for it. I think there are a lot of people in the world who see the value of great photography and are willing to pay that premium.

Are you wondering how you get to the point where you're priced correctly? Well, there's no simple answer to this. It happens over time. You have to experiment with pricing. Raise it and see what happens. You might be pleasantly surprised. We kept raising our prices every three months until we found a place where we were happy with our income level and our clients were still willing to pay for our services.

The Value of the Brand

Now, let's take a quick look at how your pricing creates perceived value for your brand.

If you're the low-cost provider, in essence you're providing a commodity product. Through price alone, you're signaling that your product or service isn't valuable. That's the wrong message to send any prospective client. You're devaluing your own business, and you don't even realize it.

I run into photographers every day who tell me that their clients don't value them, their clients don't want artwork in their homes, their clients don't this or that. That's because the photographer is attracting the wrong kind of clients. These are clients making price decisions. They don't care about your artwork; all they care about is getting the best possible price. Once that happens to your business, you're screwed. It will be an uphill battle the rest of your career. Bad clients refer more bad clients.

The common misperception here is that if you raise your prices you won't book any business. That is 100 percent false. The complete opposite will happen to you. If you raise your prices, you'll stop booking bad clients. Not only will you continue to book business, you'll begin to book the right clients as well.

Pricing is an amazing thing. Charge more and consumers automatically make certain assumptions about your brand. It has to be better if it costs more, right? Now, I'm not suggesting that you go off and just raise your prices without offering a better product or service for your clients. This approach will undoubtedly lead you down the wrong path. It's a simple exercise to understand consumer perceptions and how they impact buying behavior.

If your ultimate goal is to build a luxury brand, one that clients lust for, you have to charge the right price for that. And that's never going to be inexpensive. In our local market, we're one of the most expensive studios in the area and our business has exploded ever since we started raising prices.

We started to attract better clients—not only ones who could afford us, but ones who couldn't afford us either. "Whoa, wait, Sal, you're telling me you're booking clients who can't afford you?" That's right! Think about it. We all know people who can barely make ends meet but have a 60-inch flat screen TV. Where did that money come from? It's simple. Everyone has money for what they want to have money for. It's about priorities.

My client is a client who sees the value in great artwork for their home. That client is willing to make sacrifices to get that great artwork. Why? Because they see the value in what we're offering—and because of our price point, they understand we're a limited resource and not everyone can afford us. That immediately leads to huge perceived value of our brand. I don't have to force people to spend money with us; they want to spend money with us to get access to this amazing limited resource: my time and artistic talent!

Establishing Value

How you establish value for your clients can make the difference between being seen as an expert in your area or being seen as just another shoot-and-burner. What are you offering beyond the click? That's the question that has to be answered.

Everyone is a photographer today. We all know a friend or family member who has a camera and can do the family, wedding, or senior pictures for

next to free. How can you compete with that? For most photographers, they try to compete on price. Well, hopefully I've drilled into your head that's the worst possible way to compete.

Instead, you want to compete on value. You want to offer clients as much value for the dollar as possible. You do this by offering high-end products and services—something not found with that friend or family member—and definitely something not offered by the shoot-and-burn photographer.

Service

I can't stress this point enough: Without service you have nothing. This has to be the cornerstone of your business model. Take care of your customers, and they'll talk about you for years to come! Everything you do has to focus around the customer and the best possible service you can offer.

Susie Photographer can't offer any service because she charges $50–$100 for a session fee and hands over the DVD. She can't afford to offer service. That cousin who has a camera and did the family pictures can't afford to offer good service either. After all, they're a family member, not a business owner. They don't care about service. They did this for free.

So where does service begin and end? Great service starts when that initial email comes in, and it ends when the final product is placed in the client's hands. Arguably, service should continue for years to come, but I'll save that conversation for another day.

How long does it take you to respond to client emails or phone calls when they come in? Too long, as far as I am concerned. We respond to 90 percent of client emails in less than 12 hours. Sure, there are occasions when you need to do a little research before getting back to the client. So, what's wrong with letting them know you got their email and will get back to them as soon as you can research their request? The worst thing you can do is nothing. Lack of communication is the worst possible thing you can do for your customers. It will always lead to frustration and misunderstanding.

How long are you making clients wait to see their images? If you're not showcasing their images in two weeks or less, you're once again providing bad service. People don't want to wait two months or more to see their

images. They are excited. They hired you for great images and you're having them wait 6, 8, 12 weeks to see them? The excitement has worn off. More than likely, they won't spend money either. And what about that referral? Good luck with that.

You have to provide exceptional service in both a tangible and intangible way. The one thing to understand: This is a journey, not a destination. Every year we're looking for new and better ways to improve the customer experience. For example, whenever one of our clients books our top senior package, we offer them a free family session. That's a level of service that our competitors don't think to offer, and it blows our clients away every time. They already love us and understand the process; why not give them another opportunity to work with us and get images for the entire family? This is a no-brainer.

Service doesn't have to cost money. It just requires thought and effort.

Products

I hope your takeaway from the chapter isn't this: "Hey, Sal said raise prices and I will book more business." No, that's not what I am saying at all. Take my statement in context. You have to take care of all the other housekeeping items as well.

One of those items is unequivocally going to be your product offering. We don't offer to shoot and burn in our studio. I find it to be an incomplete service to our clients. I want to deliver high-end products to our clients that they'll enjoy for years and generations to come.

When you're charging next to nothing for your services, you don't have the ability to offer your clients high-end products. This is case number one for raising your prices.

What type of products do we offer our clients? The number one item we offer to our clients are unique albums—not only in their design, but in their quality and leather options. Regardless of the type of client—wedding, family, baby, senior—they all lust after these high-quality products. It allows us to charge a premium for our services. Think about it. What client doesn't want an heirloom-quality product for their family to enjoy for generations

to come? All of our clients love knowing they have an option beyond the DVD to display all their amazing images.

Just so we are in sync, know that this concept holds true no matter what industry or niche you're focused on. If it's not albums, then what is it? What products can you offer your clients that get them excited to work with you and allow you to stand out from the crowd? For our studio, we are on a never-ending search for those products. We go to trade shows every year looking for that new product we can add to our offerings to stand out in an ever increasingly competitive market.

Offering your clients a DVD is almost a joke to me. What are they going to do with it? Most have no clue. They just feel like they need it. Instead, show them what to do with it. Show them what you think is the best way to display their images. After all, you're the expert, right? Taking this extra step helps establish your value even more.

Packaging

How are you delivering the products to your clients? Our studio packages everything we have in a very professional way. We don't deliver them in a loose box. I want my clients to feel as if they just got the best gift in the world.

The way you package your products says a lot about what's inside the box. Do you value your products? Then show the client this. Show them from the minute you deliver the product to them.

Nothing goes out of our studio that is unbranded! Everything. Every package. Every bag. It all has our logo and coloring on display. It's the final piece in your overall customer experience with your studio. Make it count.

A common quote from our clients is something along the lines of, "Oh my gosh, I don't even want to open it. It's just like a gift." Yes. Yes, it is. And that's exactly the response I am hoping to evoke from my clients. In return, they're extremely protective of their albums and prints because I am signaling to them that this is precious cargo.

And note that this doesn't have to be expensive. First, make sure your branding is in order. Then, look for suppliers that can provide you with kraft

paper that matches your look and feel. Pick up some ribbon that matches. Get some bags made. All these things are inexpensive. Maybe it costs us $10 per order on packaging. If you're charging correctly for your work, this should be a nonissue, and it will blow your clients away.

Creativity

Your creativity has to be part of your X-factor. This is where you have the ability to shine above the rest. Show that you're an expert. Show that your work is different from the competition.

For us, this is one of the easiest ways I've found to separate ourselves from the competition. We try every week to do something new, something different. I want to get people talking about our work. I want to provoke thought and conversation. That's my goal as an artist.

You might be wondering how to do this. For me, I read, read, and read more. I love to flip through magazines and read about new lighting techniques and trends. It gives me inspiration. I then use that inspiration to try new things with my clients. And in return, clients are constantly blown away by our level of creativity.

The same holds true with our product lines. We're always looking for new and innovative products to offer our clients. They see that as another level of creativity. We show them new ways to display and enjoy their images.

You have to find a way to push the limits for yourself as an artist. If not, you'll get stale, and your work will look like every other photographer out there. Find someone who inspires you and study their work. Study the lighting and the posing. Study the composition. And then find ways to incorporate those inspirations into your next photo shoot.

Experience

When all the dust settles, it's all about the experience the client has with you, and as you know, this is all tied to everything you have done with them from that first email until the final product is delivered.

That being said, what can you do to create a better customer experience? You must challenge yourself and your studio to raise the bar. It's this experience that will establish value for your brand in your local market—in any market.

Our clients tell us all the time, "You were worth every penny." That's an amazing feeling for us. That's how we want our clients to feel. If they feel that way, they'll spread the word and become our best marketing brochure. You can't buy that kind of publicity.

I firmly believe that we offer a high-quality product and service. However, I think the number one key to our success is giving our clients an experience of a lifetime. It's that experience that creates huge perceived value and allows us to be more than just "another photographer."

Next Steps ▶▶▶

What will you do tomorrow to change the client experience and offer a service that is second to none? I want you to think of two things right now that you can do, starting tomorrow. Write them down, and then go execute them immediately! Here are two things I think any studio probably has room for improvement on: 1) returning emails or phone calls quicker, and 2) getting clients their images faster. Make those two changes, and I promise you, your business will immediately stand out from the crowd as a top-notch photography studio.

In addition, get out your pricing sheet. Make sure everything you offer is listed there. Now, I want you to write next to every single item you sell the hard cost of that good, including shipping, tax, and similar factors. What does it cost you at the absolute minimum to get that product to your studio? You should always have this information handy for reference. I know, within a few clicks on my computer, how much a product or package is costing me to fulfill for my clients.

Next, take out your pricing sheet and compare it to what we are doing. See where you can make improvements and adjust your package structure to meet what we have laid out here. Make the changes, put it out there, and see what the results are. Don't freak out if it takes some time to get traction. Think about it—you're changing your business model. It's going to take time to flush out those bad clients and get to the ones who appreciate what you're offering and will accept the new process and pricing you have laid out, but you'll be better off in the end. Trust me on this. I speak from a place of experience.

And finally, sit down and start mapping out what you want the client experience to look and feel like within your studio. A great exercise is to pick a brand you truly admire and go through their experience. For us, we use Louis Vuitton as a model for our business. We went into the store, made a purchase, and enjoyed the client experience. From there, we took away many valuable lessons and ideas that we have quickly incorporated into our business. One example we incorporated: They offer their customers champagne or cappuccino when they are in the store. Now we do the same in our studio (and no, high school seniors don't get champagne!).

Web and Social

I WANT TO begin this chapter by saying that this chapter isn't a do-all, end-all on Internet and social media strategies. The challenge with most of this stuff is the time it takes to publish information and the amazing frequency with which it changes. Algorithms, strategies, and information are all changing at an unprecedented pace. And truthfully, there are no signs of it slowing down. This is why I believe older studios struggle so much with this issue. They're used to implementing a strategy and then expecting it to last a year or more. Today, your online footprint is changing at a damn near daily pace.

Use this chapter as a guide, not a rulebook. Doing so will allow you to have a healthy outlook on things. Don't get overwhelmed by the pace of change. Embrace it. If you have a solid overall strategy, changes in the industry won't break your system. Your system will bend to these changes, and that's the best-case scenario.

Why It Matters

This is the future! Wake up. More people are likely to find you online than ever walk into your storefront, if you even have one. Most of us today don't function via walk-in business. And if you're working out of your home, how do you see that working?

Your digital storefront *is* your place of business. Stop resisting it. Stop putting it off. Imagine if you owned a brick-and-mortar store, and your business was truly based on walk-ins. Would you have crappy pictures on the wall? Would you have a location that hasn't been updated in 10 years? Furniture from your grandmother's house? Okay, maybe you'd have some of grandma's furniture because it looks so cool right now, but the point is still valid. Of course not! You'd work on your space and make sure it was spot on.

For some strange reason, when it comes to our digital storefront we're just straight-up lazy. There's no other excuse for it. We procrastinate. We don't understand it. Seems pointless. Yet, we can't seem to figure out why the phone isn't ringing. Guess what? It's because people go to your website first! And if they don't see what they like, then there's no reason for them to call. Boom! Done! There it is. Get your website and social presence in order—stat. Your potential clients are judging you and making decisions without you getting to say a word about it.

Where to Focus Your Energy

Okay, so let's pretend you understand why it matters at this point. I know what you must be thinking. "It's a daunting task, Sal. Where in the world do I begin?" Well, let's come to an agreement. You're not a developer. (Okay, maybe some of you are. I actually was, but that's a story for another day.) The bulk of this book's readers are not. I don't expect you to be. Don't waste your

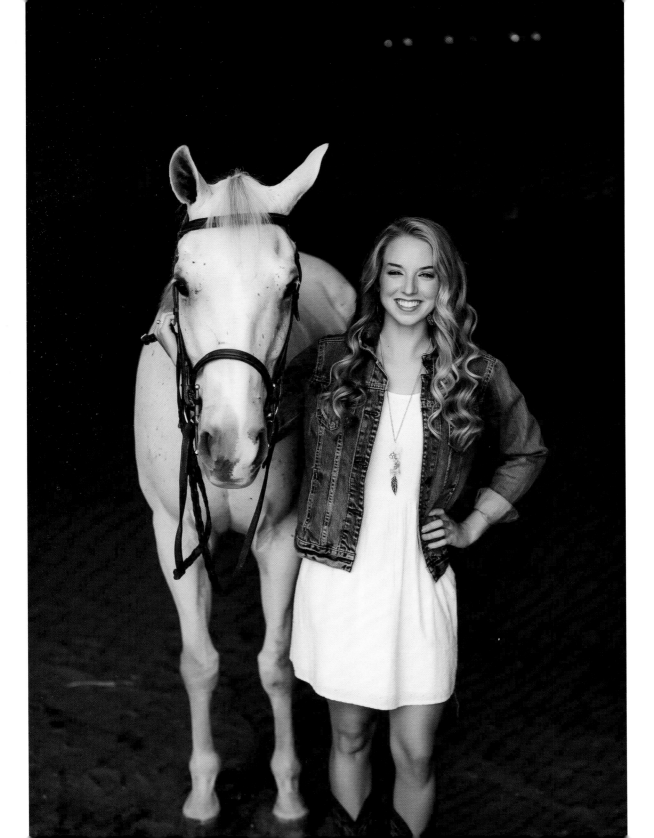

time and energy trying to be. You're a photographer. Plain and simple. Focus on what you do best: taking pictures. And if you're no good at that, well....

This is where I see a lot of people fail. We all have the best intentions, but sometimes we have to leave this kind of work up to the people who are good at what they do. Accounting, legal advice, logos, branding, Internet, websites, SEO, etc. It will take you longer to figure all this out than it's worth in dollars to just pay someone to do it right.

Focus on your strategy and let someone else help you implement that strategy. That's how you'll find the most success. Let me give you a little perspective. I was a developer for most of my career for Microsoft. I know how to program, but I had nothing to do with programming work on any of our sites. Yes, understanding technology helped me have conversations with my developers in order to communicate my goals and strategies, but I didn't spend any time on the labor. Now, that makes solid business sense. That's where I want to see you focus. Understand your strategies and find people to help you implement them. Yes, it will cost you money, and you might think you're wasting that money. But trust me, you're not. When all is said and done, it will be done and it will be done right. If you treat it as a DIY project, like most projects in our lives they'll never get done and, if they are, they'll rarely be done right.

So, where to begin?

Facebook

Yes, the current 800-pound gorilla of social networking. Will it remain king forever? Who knows? Who cares? If not Facebook, it will be some other entity, but for you, all you need to know is how to harness the power of this medium.

Do Not Use Your Personal Page

Under no circumstances should you build your business using a personal page. When you start on Facebook, you must have a personal page. That's the beginning. From there, you can create a business page. Your personal page is just that—personal. It's for friends and family. Not to mention, there

is a 5,000-friend limit. You might think that's a huge number, but as your business grows and your fan base grows, you'll realize that it isn't a big number at all. My personal page has 5,000 people.

I see a lot of photographers who are just starting on Facebook, and they start driving traffic to their personal pages. Then, when things get going for them they have a hard time converting that traffic and those followers to their business page. Also, your personal page requires a confirmation in order for them to be a friend. Your business page just requires them to click "Like." Big difference. Make it as easy as possible for people to follow you no matter what social media you're using.

Start Multiple Business Pages

Here's the thing. It's free! Create as many pages as you like. For our studio, we use one business page for our high school seniors and another for our weddings. Why? It's simple, and my seniors don't care about my weddings and my weddings don't want to see seniors.

Doesn't matter what genres you have—consider separating them into multiple business pages. It's much easier to control branding as well, which is something we'll talk about shortly.

Fill out all the information for your business page. It's important that you have all your contact information filled out so that you can drive people back to your site or to a phone call if they decide they want to know more.

Generate a User-Friendly Name

Go to your business page right now. Look in the URL. Does it look like this: www.facebook.com/123455^$$599r? If so, then you need to fix that. It's a simple thing to do; you just have to do it. It's much easier to say, "Hey, check out our Facebook site at facebook.com/salcincottaphoto!" than it is to say all those random numbers and letters. Not only is it easier to pitch, it just looks way more professional.

You have to realize this isn't "just Facebook." For many people, this business page acts more like your storefront than your actual website. Things become viral here. People share, like, and comment. There's a community here that can do things that aren't even possible on your website.

Brand It

Believe it or not, you can brand your Facebook site to a certain extent. You have the ability to control the timeline image and the icon. We use different branding for each site we have. So, our seniors site has a certain grungy look compared to our weddings site, which has a classic feel.

It's worth a bit of effort to keep your Facebook presence somewhat synergetic with your main brand so that you have some common thread.

Not only should you try to introduce some level of branding to everything, but you should update it somewhat frequently—my recommendation is to try to update monthly. Change out that main banner, and put images up there that represent your brand so that you can attract the kind of clients you want.

Also, when it comes to your icon, don't use a client picture. When you're posting, this icon becomes a branding tool. So, if you use a random portrait client, then they become the face of your brand; once you change it, a new image starts showing up on everyone's timeline. It's confusing and the branding is lost.

Link It

Facebook is a great tool, but when all is said and done, I need to drive traffic back to my site. Facebook, is well, just that—Facebook. They change things whenever they like, there are no strong branding options, and there's no easy way for people to see and experience your brand.

You need a way to drive traffic back to your site, where you're in full control of the experience. To that end, Facebook has a very cool feature—if you take a link from your website and enter it into your status, Facebook will automatically pull back a blurb from your blog and a picture from the post and include that in your status update. This is a very powerful feature, in my opinion. It's the best of both worlds: You can have content on Facebook and then drive people back to your site to see more of your work.

I want people going to my main page. There, they'll have a branded experience. Also, think about this. Because I keep separate business pages at Facebook, my high school senior clients might not even know there's a wedding side to our business. You'd be surprised how many weddings I've booked off of senior client referrals, and vice versa. This is because I'm driving them back to our site and ensuring that we're cross-promoting our businesses. This cross-promotion also allows us to multipurpose some of our content rather than trying to reinvent the wheel over and over.

Ads

Try it. Don't shake your head. I don't care what you've heard, either good or bad. Just try it. See if it works for you. That's all that matters. There are multiple ways—and counting—to promote your posts, your sites, your special promotions.

I don't particularly care to run the paid ads that show up on the right side of the screen. Personally, I've never had much success with them. However,

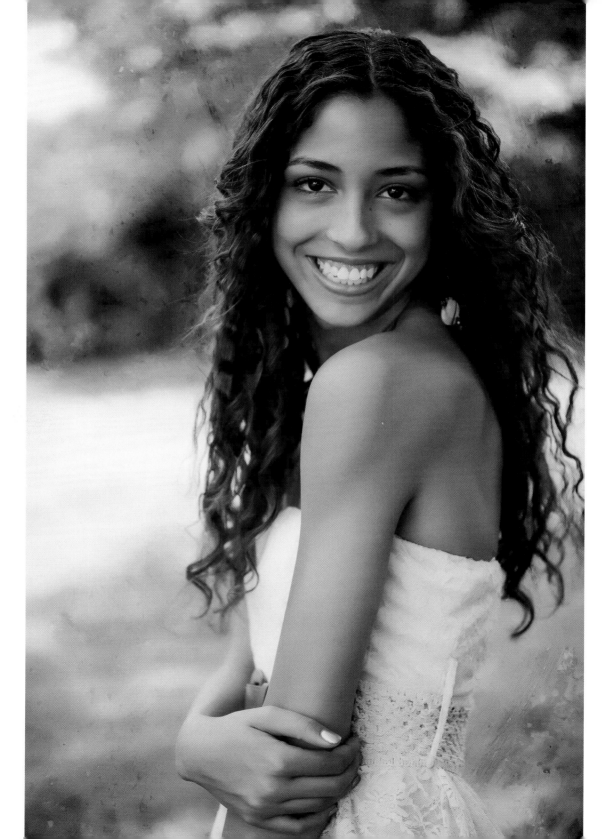

there's an option to promote your posts. This is extremely important. See, without getting into how Facebook works, know that just because you post something on your page doesn't mean that everyone who is following you sees it in their newsfeed. This fact can be frustrating for people who don't quite understand the whole Facebook phenomenon.

Facebook has this algorithm thing that gives you what they call an "Edge-Rank." In a nutshell, what this means is that Facebook is determining what shows up in everyone's newsfeed based on what they think is relevant, which itself is based on a host of unknown and top-secret metrics. Well, there's only one way around that—paid posts.

Paid posts allow you to pay a nominal fee and get more people to see your posts. From time to time we'll take advantage of this to get the word out and get more people to see a special promotion we're running. Like everything else, just try it. If it doesn't work for you, move on to something else.

Twitter and Instagram

If you don't know what Twitter is at this point, we have our work cut out for us! This won't be a Twitter tutorial, but just more of a guide on what to focus on and where to spend your time.

I use Twitter. I don't love Twitter. To be honest, I find it to be almost useless. Twitter is a social tool that limits you to a certain number of characters. Yes, characters. We are photographers. Not characters. (Well, I'm a bit of a character, but not in that sense.) If you're trying to create buzz for your photography business, I don't think Twitter is going to help you. As an author, yes, Twitter is a great tool for me to keep in touch with my fan base of professional photographers. Do you know what I tweet about? Pictures. It's kinda funny.

When it comes to high school seniors, I find that 98 percent of them aren't on Twitter. Once they go off to college, we've seen a handful of them start to follow us on Twitter, but for the most part our seniors are just not there. When it comes to seniors, I think your investment should be minimal on this platform. Something that's growing by the minute is Instagram, which—go figure—is a recent Facebook acquisition. The kids are all over this right now. It's a photo-sharing platform using your mobile phone.

I'd rather see you give Instagram a little tour and try integrating it with your business than spend lots of time with Twitter. At first, I promise you're going to be like, "What the hell is Sal talking about?" At first, I was wondering what the hell I was talking about. The kids love it, though. It's the Twitter of photography. Use it in conjunction with what you're already doing. Use it to post behind-the-scenes photos. Then the kids will tell all their friends about it and follow you on Instagram. It's a great way to engage with the kids.

I'm going to warn you, though—Facebook hasn't done much with Instagram since the acquisition. It's a rudimentary tool, but it serves its purpose. A cool, fairly new feature of Instagram is the capability to share short video clips. This feature is so new that I don't have a whole lot to share with you at this point, but rest assured, we're already looking at how to integrate it into our business.

Google+

I wish I had some good news for you. Unfortunately, Google is playing catch-up to Facebook and I'm not sure they're running the same race. I have a Google+ account. I logged in a few months ago, I think. Just being honest.

I can't speak too much to the platform, but as I've been saying, try it. See if it works for you. I can tell you I have practiced what I preach and tried it. And unfortunately, the kids are just not there, at least not in my market.

I find Google+ to be used more in the corporate world. And this may work for your main portrait business or even your working relationships, but the kids are all over other platforms right now, which, of course, isn't to say that won't change over time.

Google+ tends to be a me-too platform. Its sole existence seems to be to compete with Facebook, and as a business model, that approach rarely works. Google+ doesn't have anywhere near the number of features as Facebook, but I can tell you that the Google+ interface is gorgeous. And for the features it does offer, it does it well. Here's my humble opinion as to why I believe my seniors favor Facebook—it's where all their friends and family already are. Bottom line.

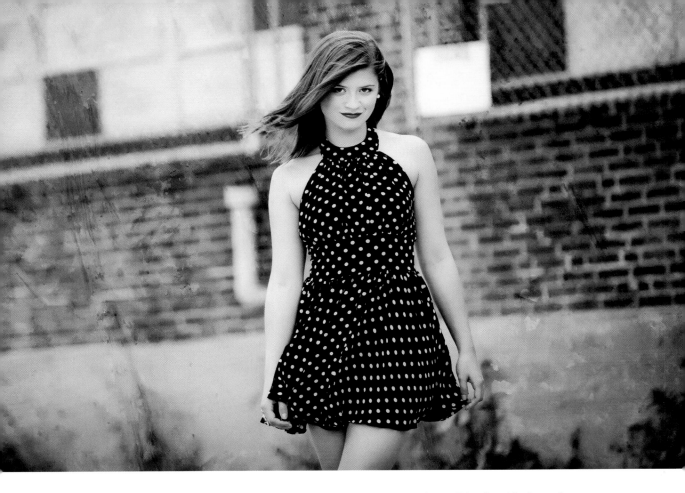

I don't blame Google. I don't knock the platform. It's about being where my clients are. Now, again, that being said, you shouldn't ignore the platform. You have to be aware of it and watch trends. As you see more and more clients moving in that direction, ramp up quickly and get there before your competitors do.

SEO

SEO: search engine optimization. Come back, come back. Don't run away. I know, it's going to be okay. It doesn't have to be complicated, I swear. I'm not going to write an entire section on how to be an SEO guru. There are 500-page books and blog posts that do that just fine. Instead, I'll give you tips and tricks to consider in order to improve your SEO ranking.

Why?

First of all, SEO is organic. I know, it already sounds horrible. Seriously, though, we've spoken about all sorts of advertising and marketing strategies that cost money and lots of time, but SEO can be free. Yes, *free!* When I ask a client, "How did you hear about us?" there's no better reply than the answer, "I found you on Google." Hell yes! That's free, baby! Not effortless, just free. It's going to require some time and energy, but the results are priceless. Go test this out. Try a Google search for your core business. Forget seniors for a second. For our studio, weddings are our primary business. If I Google "St. Louis wedding photography" we come back on the first page of results. That's huge for our business. It took several months and lots of hard work, but it can be done in your market as well.

The value here is in the business and traffic it will drive to your site and, ultimately, the dollars it will bring to your business.

If you're showing up on page 3 of a Google search, or even further back, it's useless. Have you ever gone through five or more pages of Google search results? I've never gone past the first page to look for a company. That's how important this is to your business.

You have many options out there. There are companies promising you page 1 results, "consultants" who will work on your site for you, and hosting companies promising that if you use their platform you'll rank. Not sure there's much to any of this. After all, it's not that complicated; with a solid strategy in place, almost anyone can rank well. To give you perspective, in our Google search results we rank higher than TheKnot in our local market. This is a company that spends a hell of a lot more on marketing their business than we do. Not to mention, they have a staff that would dwarf mine tenfold.

Okay, so what should you focus on?

Site Type

Flash-based sites *do not work!* Don't let anyone tell you otherwise. "Meta tags" just don't work. Google and the other major search engines don't pay attention to Flash sites the way they do other kinds of sites. The reason is

simple. There are multiple factors that go into ranking your site. The biggest factor is *content*. Content is king. Well, when you have a Flash-based site, most of your content is hidden from Google and your site will suffer because of that.

Not to mention that Flash doesn't work on iPad or iPhone devices. Do you really want to ignore this part of the world for your senior business? No, you don't. In fact, all those sites that promise to deliver "mobile versions" of your site do nothing to help your SEO.

You want an HTML5-enabled site. Yes, you can have something based on a template—there are a ton out there—or you can have something custom developed and designed for you. Either way, this is the better solution for your SEO needs.

And let's take it a step further. We opted to have a WordPress-based site. At its core, it's a blog. And Google *loves* blogs! They are search-engine friendly and make it super easy for you to optimize. They're platform independent, which means that they'll work on mobile devices and computers alike. This is what your site should be based off of.

You can find a bunch of free templates for WordPress sites. Now, just so you understand, I'm not suggesting you host your site at WordPress. Almost all major hosting companies allow you to install and host a WordPress site on their platform for a minimal monthly fee. This is where I recommend you start looking.

Once we get the platform right, we need to start focusing on some things that matter to the search engines. Oddly and happily enough, all of these require no programming skills, as some companies would have you believe.

Copy

Copy or, in simpler terms, text. And lots of it! Don't underestimate the importance of this. Write relevant copy. Sure, we've all seen those blog posts about how gorgeous the sunset was and the bride was beautiful, or the senior was having a blast and it was a gorgeous sunny day in June. To that, Google just doesn't pay that much attention. It's just not that interesting... unless you use *keywords*.

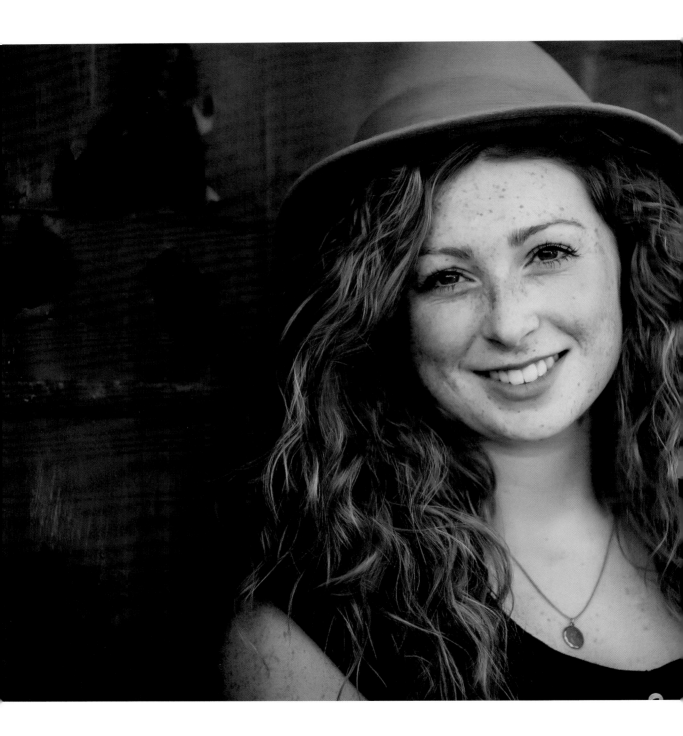

Keywords, you say? What are those? Well, they're the words that will help people find your site when they search Google or any other search engine. So, unless you're hoping for people to search for "gorgeous sunny day in June," you better figure out your keywords or you'll never be found.

Instead, write all about that great day, but interject with keywords that will people find your business—"it was a gorgeous sunny day in June for this St. Louis high school senior photographer." Now we're cookin'!

See, it's not enough to just write copy, and it's also not enough to just put your keywords in sentence format over and over again like "St. Louis senior photographer St. Louis senior photographer St. Louis senior photographer..." as some people do. The search engines will penalize you for this type of behavior.

When writing your posts, write sentences that integrate your keywords. No programming is required, and it can be implemented immediately.

Image Names

When you post to your blog, how are you naming your images? Are you naming them "xyz123.jpg"? That's useless to search engines! They don't know what that means. Consider using your keywords here, too—for example, "st_louis_senior_photographer_123.jpg." Imagine what this does to your page ranking. Now when the search engines look at your site they're seeing tons of relevant keywords listed, including your images.

This process doesn't have to be complicated. We use Lightroom to export and resize our images. Built into the tool is the ability to rename your files on export. Regardless of what tool you use for your image sizing and exporting, you always have the ability to rename the images. Take advantage of this little trick to get more keywords on your page and increase its relevance.

Age

No, not your age—the age of your site. Believe it or not, you can't start up a brand-new website and think it's going to rank well right out of the gate. The search engines reward seniority. The longer your site has been around, the better it will do. That doesn't mean you can't rank well for a new site. It's

just that, all things being equal, an aged site will see better results—plus it will be harder to knock older, well-established sites off the top of the ranking charts.

Header Tags

In a nutshell, this means Bold (for the nonprogrammers out there). Within HTML code there are tags. And though we won't explore HTML coding, these tags are looked at by Google to determine the importance of certain content on your page. "H1" tags will typically make your copy a heavier font—it looks bold, but behind the scenes it's tagged H1. Don't let this intimidate you; most website tools allow you to select text and mark it as a certain type of text. In this case, we'd make it H1.

All of this is great, but the most important part isn't how you do it, but why and what goes in there. You do it because it signals to the search engines and your readers that they should pay special attention to the text that has been selected and marked up.

Now that they're paying attention, the "what" matters. What you place inside these tags—the text itself—is equally as important. And if you guessed keywords, you'd be right! Your keywords must be part of your headers for each post. For example, if you were to use "Fun senior session with Susie" and make that the H1 for your blog post title, the search engines would, once again, just not pay much attention. It's useless for SEO. Now, the smart blogger would post something to the effect of "St. Louis senior photography with Susie"—this is gold for your SEO!

This is by no means a comprehensive discussion of SEO. I'm merely scratching the surface and giving you some tools in your box. And guess what, by next week, the search engines will come up with new things to consider in your quest for SEO dominance. But these basic principles are solid. And the great news is that, for everything we just talked about, no programming is required. These are things you can start doing today.

Next Steps ▶▶▶

Where to begin? There are so many possible next steps. It all depends on where you are in the lifecycle of your Internet presence. The exercise you should explore next is to take a look at your social media and website presence, and consider the following:

How do I stack up compared to larger companies? Don't just compare yourself with other photographers.

Set up your Facebook page per my suggestions.

Take a good hard look at your Internet portfolio—get it together.

Ask friends and family for feedback on your website and ask them to tell you honestly what they think. Ask them to give you three words to describe your site, and if those words don't match the three words you'd use to describe your brand or company, there's a problem that needs to be addressed ASAP.

Finally, put a social media strategy and calendar together. Commit a certain amount of time each week to do something on your website. Trust me; it's easy once you make this part of your weekly ritual.

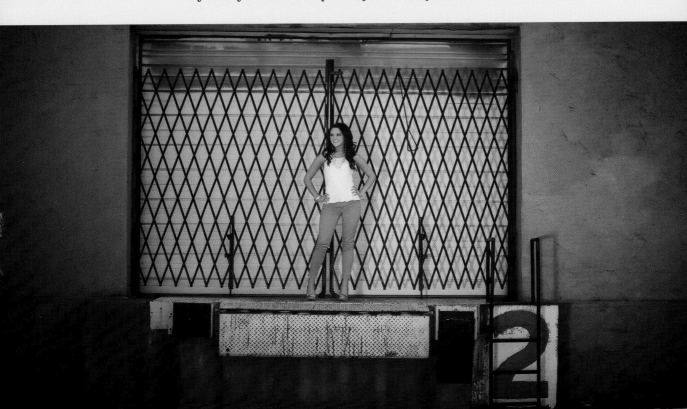

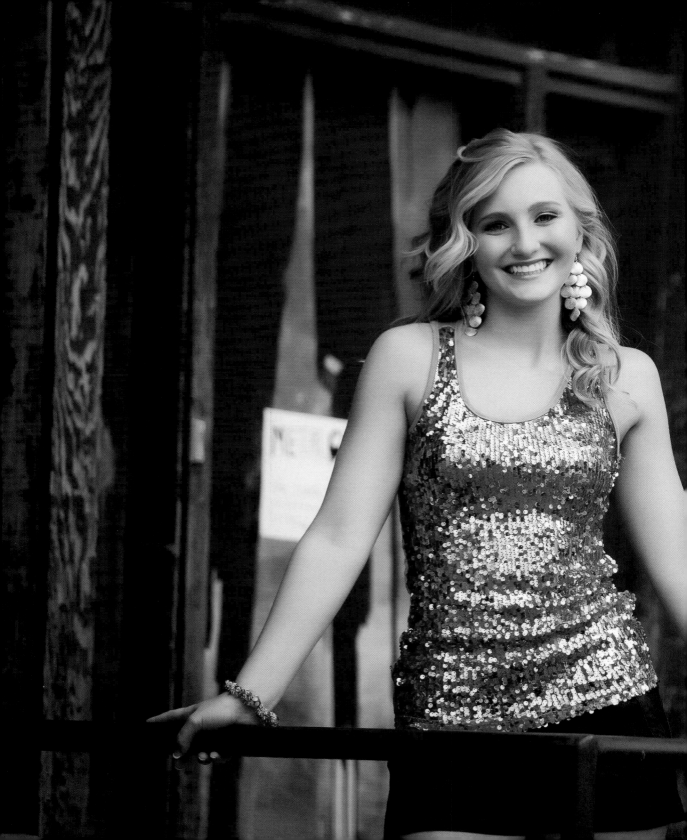

The Sales Process

YIKES. SALES. RUN. HIDE. We don't want to sell. We hate selling. It's so...so confrontational. "I'll just post them online and let my clients pick on their own. This way I don't have to talk to them." For the love of everything holy! Get it together, man! You're a businessperson. You're an entrepreneur. You do not just leave the sales process to a lame website ordering system showing images in low resolution with no context, no help or guidance, and no way for the client to see or touch the product. That's not just bad business, it's stupid. It doesn't work. Not because Sal said so, but because you can't look to any successful service business and see this hands-off approach work. You need to engage with your clients and work with them through the *entire* process, not just the fun parts.

The truth is, sales is not that bad. If done correctly, you'll realize it's actually fun and extremely rewarding. Best of all, you don't have to have a pushy car salesman attitude to have success. Instead, I encourage you to see yourself as a guide through the process versus being a sales associate. Once you come to that recognition, you'll realize it's pretty easy.

Here's an overview of the sales process and what we'll drill into in this chapter:

- The value of selling face to face
- Home versus studio versus client home
- Selling versus guiding
- Timeline of events
- The sales session
- Final delivery

Selling Face to Face

Here's a reality check for everyone: You must find a way to sell face to face. There's just nothing more powerful than that. I know, because we've tried. Nothing would make me happier than to shoot a session, get home, post the images online, and watch the cash roll in. Unfortunately, it just doesn't work that way. And more than likely, it never will. It's human behavior. There's nothing we can do to fight it. Many photographers promote these amazing websites where you can shoot and load your images for sale, but I believe that's a sign you gave up on your business.

Sure, some people want to view the photos online—family members like grandma, aunts, and uncles in different parts of the country and world—but we're talking about the 80/20 rule here: 80 percent of the time, your clients need to meet with you so you can take them through the process, give them an experience they'll never forget, and be there to answer any and all questions they may have about products and image choices. Your business will never survive appealing to the 20 percent. Focus your energy on the 80 percent and that's how you will grow and thrive in any market.

This is a major purchase. Clients want help; they want guidance. This is why they came to you, no? Wait. You're not one of those people who think they came to you for your amazing artwork, are you? Clients today want an *experience*. Get it through your head. They can get photography literally

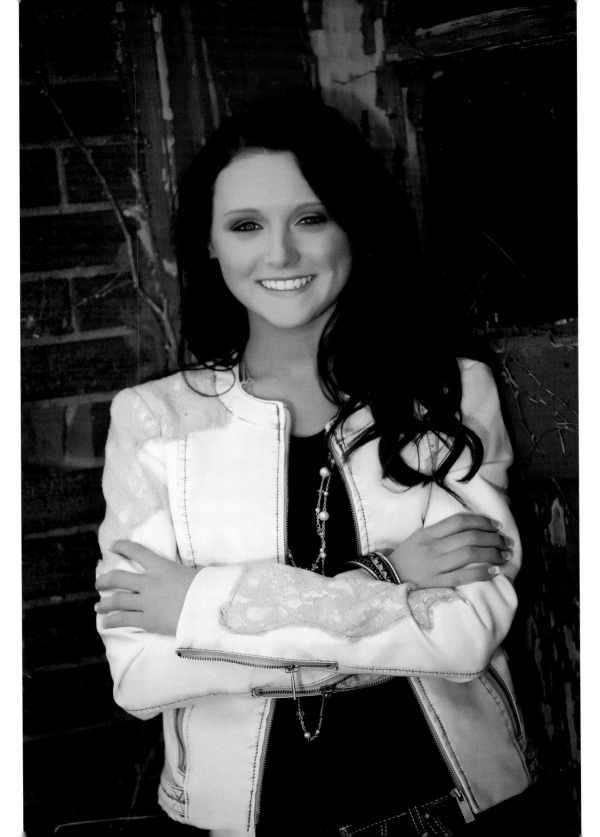

anywhere and everywhere. But it's the experience they can't get anywhere else. Bringing your clients in establishes you as the trusted adviser.

Here's what I'd like you to think about: What kind of high school senior business do you want to run? One that is high–volume/low-profit or low–volume/high–profit? The choice is yours to make. I obviously know how I feel. I'm a limited resource, and therefore I can't run a low–profit/high-volume studio and last in the long term. That being said, I want you to continue this thought process. Which is more personal? Selling online or selling in person? Again, the answer should be somewhat obvious. Selling in person is and always will be more personal. Continuing down this path, can you tell me of a business you know of that's highly profitable, expensive, and impersonal? Um...yeah.... Are you getting the picture here? There are none.

People spending money want service! Plain and simple. People spending money can go wherever they want. They'll go where they feel valued, somewhere they feel they're getting service above and beyond the norm. Meeting face to face with clients and guiding them through the process of selecting the right images, the right sizes, the right finishes, and so on is a higher level of service. You have to do it. You have to make this transition for you and your business.

Where to Sell?

The next step in this progression is figuring out where to establish your sales base of operation. No easy task, by the way. And it will be different for everyone. The best piece of advice I can offer is to experiment and find what works for you. We've tried many different options. Today, we operate out of our studio; I believe it provides home field advantage for us, something I'll discuss in just a moment.

If you're just starting out, don't be fooled into thinking you must have a studio. We operated out of our home for several years before we could afford an actual studio space. The important part in all this is understanding that you must actually sell. That process has to be created and must exist in your business. In fact, even if you're an established studio with a sales process, that doesn't mean your process is 100 percent solid. Every year we're looking for new and exciting ways to tweak our business and our sales process.

Selling from the Home

For the most part, this is where we all begin. Most photographers start, more or less, as a home-based business. When I began my career, I converted my spare bedroom into an office, and that's where I ran my business. We then took one of the rooms on the first floor of our house and converted that to a sales room. This was the process for about three years. It made sense and it was cost effective.

So, what should you be thinking about? Running sales out of your home is possible, but you have to think about the experience your client will have. We were very fortunate and had a nice home. We can't charge $2,000 for a senior package and bring our clients to a trailer park. It just doesn't work that way. We want them to have an experience—although, I suppose one could make the argument that if you held sales sessions in a trailer park there would be plenty to experience, but I digress.

Here are some of the benefits of running your sales from your home:

▸ **Low overhead.** Your rent or mortgage is already paid. Trust me, I'd love to still be in my home versus paying what I pay for my studio today. All your utilities are already covered. So, financially, when you're starting out this is a great option.

▸ **You're home.** We all hate traveling and getting stuck in traffic. This option allows you to spend as much time at home with your family as you can.

▸ **Ability to offer clients an experience and invite them into your home.** There's something to be said about having clients in your home. It puts everyone at ease. When we were working out of our home, my wife Taylor would do personal things like bake cookies before clients would come over and just have them out in the kitchen. This was an amazing personal touch. We'd offer wine and champagne (but not to the seniors!) in our kitchen. It became a very personal experience for clients—one that's not easily achieved in a cold sales environment.

Here are some things you have to think about before you bring your sales sessions into your home:

- **Where do you live?** Just being real with you on this. If you live in a bad part of town or a home that's just not up to par with the level of the clients you're going after, then this isn't an option for you. It will hurt sales more than it will help.

- **Do you have kids?** Nothing can kill sales quicker than screaming kids running around. I know I wouldn't want to go spend thousands of dollars and walk into a romper room.

- **Cleanliness.** Clean up your house! Seems like this would be common sense, but all too often it's not. Would you want to walk into a messy business and make a high-dollar purchase?

- **Turn off the phones.** No one wants to be distracted by noise. You should be laser-focused on the task at hand.

- **Samples.** You have to have samples of everything.

- **Minimize distractions.** This includes a noisy spouse, kids, and phones. You're trying to create an environment and an experience. Make sure you do everything possible to achieve that.

Selling from the Client Home

Another option is to bring your sales process right to your client's home. Like all things, there are pros and cons to this as well. In my career, I've done this a few times with very good success; however, I've had some challenges too.

Here's what I like about selling in the client's home:

- **No studio space required.** No rent, no mortgage, no overhead. Very economical from that perspective.

- **Very personal.** You're going to their home. Definitely a higher level of service. Reminds me of a tailor I recently used. She came to the house to custom-fit shirts for me. The level of service was over the top. The funny thing was, the shirts were about the same price as a dress shirt in the store, maybe 15–20 percent more. But the level of service provided made spending that extra money well worth it.

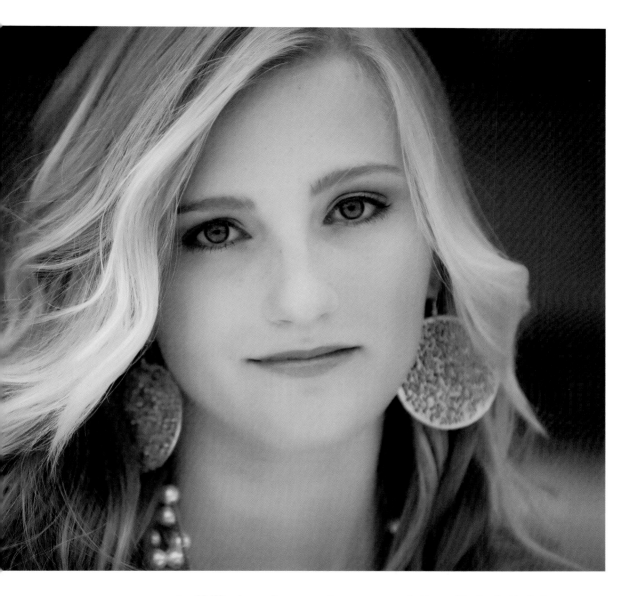

▶ **Ability to make accurate recommendations.** You're in their home. If you have any sales or trusted adviser status, you should be able to make suggestions based on what you're seeing in real time. Now, when that client tells you they want an 8x10 for over the fireplace you can show them exactly what it will look like and that should be nothing short of ridiculous.

Now selling from the client's home is not all smooth sailing. There are definitely some less-than-positive things to consider:

▸ **Life gets in the way.** Once clients know they're meeting at their home, they tend to be a little more lackadaisical. Dad shows up from work late, mom is cooking while you're trying to walk through the process, and so forth.

▸ **No control of the environment.** You lose home field advantage. Phones are ringing. Dogs are barking. Kids are running around with no control. It's completely different than having them in your facility where clients have to be there, finish, and then leave.

▸ **Presentation equipment.** You have to be careful here. I wouldn't recommend using your client's TV. Suddenly you're at the mercy of their connections, lighting, and so forth. And all that work you did on color correction will be lost on your client's typically inferior and uncalibrated equipment. This can't happen; it will without a doubt impact your sales.

▸ **Samples.** You have to have samples to show. This would be true even if they were in your studio or home; however, the difference is you have to have a traveling roadshow with you and that can sometimes be tough to do.

Selling from the Studio

Today, we operate from our studio in a suburb of St. Louis, Missouri, about 30 minutes from downtown. I've heard the argument—or fears, I should say—that clients won't travel to me. Not true! They will travel. We have clients who travel for 45 minutes to 1 hour to get to our studio to see their pictures. Clients will travel and they love the experience. Trust me.

Ultimately, as I look back over our career, getting to the point where we're selling from our studio is a good thing, and I think it's something you should definitely aspire to. It makes the entire process easy, and it sends the message that you're a legitimate business and more than just a weekend warrior.

Here's what I like about selling from the studio:

- **Legitimizes your business.** Perception is reality. This tells the world you're the real deal and not some mom-and-pop operation. It helps justify the entire process and your pricing.

- **Home field advantage.** Just like working from your home, you control the environment in every way, shape, and form. You'll have a captive audience.

- **Your sales room becomes your showroom.** Everything you offer will and should be there in the form of a sample. That makes it simple for your clients to get a sense of all the various products you offer and what they'll look like on the walls.

- **Ability to provide a unique experience.** Offer champagne (soda for the seniors!), snacks, and an uninterrupted look at their images.

- **Ability to control the display of images.** Similar to working from your home, you're in control here and can make sure the images look the way they should.

Once again, there are things to think about before moving forward with a studio:

- **Expenses.** Immediately, expenses go up and it's not just the rent: electric, furniture, studio samples, various décor, and insurance, among other things. You must think about this before moving forward. Your prices have to be able to justify this move and you must have a sales process that's either in place or being developed for this move. Online sales won't support this.

- **Seasonality.** The photography industry in general is pretty seasonal. We have to be aware of this. How will you carry your business during those slow months? When you were working out of your home, that was easy; there were no additional costs to worry about. Now you have to think about this. If you're just focusing on seniors, you need to think about this. Senior shooting season is typically June through August. That's a very small window of time. What are you doing the rest of the year?

▸ **Support.** You won't be able to do it alone. Whereas you were once wearing many hats in your business, now it's imperative that you focus on the task that makes you money—shooting. If you're not shooting, you're losing money. It's that simple. You're going to need support to help clean, prepare, and edit. This is something that will be a struggle for a lot of you, but trust me when I tell you—you must shoot and keep that revenue coming into the studio. For me, my time is split between shooting and marketing. That's where my time is best spent. Everything else can be outsourced or delegated to support staff.

Selling vs. Guiding

I think now that you have an understanding of where you should be conducting these sales sessions, it's important to know the difference between selling and guiding your clients.

None of us wants to be salespeople. We cringe at the thought. It brings vivid and bad memories to that sales process we've all been part of at one point in our life. We don't want to be that person. We want everyone to love our work so much that they just open their wallets magically and spend. Well, I'm sorry to say, but it doesn't work that way, and if you're counting on that "magic" to happen you'll either go out of business or struggle just to survive.

It's funny because as I'm writing this, I'm recalling a timeshare property that I went to visit down in Florida many years ago. The experience was almost comical. At the time I was about 30 years old. I can't sit here and say I was an expert in sales, but I remember recognizing a bad sales technique. It was one of those trips that was all expenses paid, but you had to be willing to give them 30 minutes of your time to hear about their timeshare opportunities. Yeah, "opportunity." I love it. We got down there, listened to the pitch, and they started asking us very heavy-handedly if we were ready to sign. It was about $40,000 for a lifetime membership with two weeks per year at any of their certified resorts along with many other brilliant add-ons. I smiled and said, "Thank you, but we just don't have that kind of money." Next tactic: payment options. Nope. No thank you. Next tactic: She had her manager come over to see what was wrong and what he could do to make this happen. I said, "Nothing is wrong. It seems like an amazing deal, but we just can't afford it and would like to leave." Keep in mind, we were supposed to give them 30 minutes, and at this point we were there for about two hours. The catch—your hotel wouldn't be free unless they gave you their stamp on the receipt. Next tactic: They went from two weeks at $40,000 to four weeks at $20,000. Holy crap. What a deal, right? Now, I was a businessperson, so it was at that point I realized what was going on, but there was seriously no way I was budging. We didn't have the money. Next tactic: They brought in their supervisor. The dreaded boss's boss. Oh no! Next tactic: This was unreal actually; they looked at my girlfriend, who by the way had no money in this game nor had been engaged at all in the sales process, and asked her, "Don't you like to travel?" to which she replied,

"Of course I do." The supervisor responds, "Don't you think you deserve to travel and vacation in nice places?" At this point I was just blown away. I mean, just jaw-dropped blown away. Next tactic: Supervisor offered six weeks, premiere location choices, $14,000. Wow. We went from two weeks at $40,000 to six weeks at $14,000. It was at that point—more than three hours into the process—that I stood up, looked all three sales bullies in the eye, and said, "Stamp my card, we've been patient, we promised 30 minutes, we're leaving!" As I started to create a scene in front of all the other suckers in the room, I think they realized it was time to get me out of there.

Ladies and gentlemen, *that is selling!* And that is not—I repeat, not—what we do or advocate doing.

What we do in our studio is *guide*. We guide clients through the process. They need help. They're not designers. They're not photographers. They don't know good pictures from bad. That's why they're coming to you. You're the expert. They trust you. They need you to guide them through the process and help them make sense of all these amazing images and what should go where in their home, bedroom, office, and so forth.

Don't be afraid of this process and don't be afraid of what it means to guide your clients. We hate sales. I never want to be that team in Florida. But I'd be offering an incomplete service to my clients if I didn't help them. We've never had a client come through and not thank us. Once we help them, they all feel the same way. "We'd never have been able to do it without your help."

Think about it—when you post images online or just hand them a DVD, you're leaving them to their own devices to figure it all out. How can that possibly be a good thing? Plus, we agreed in the beginning of this chapter that a higher level of service comes in the form of face-to-face service.

Keep the cheesy sales tactics out of it—things like limiting the number of poses or minimum orders. We allow them to walk right out of our studio and not purchase anything at all. Does it happen? Of course it does. And we have to be okay with that. But keep in mind that these are clients who hired you. In theory, most, if not all, should want to buy something. In the end, it's all about averages. Some will buy big and spend a small fortune in your studio, and others will buy nothing.

Guide your clients through the process and you'll never sell a day in your life. The process should be fun and enjoyable for everyone involved.

Timeline of Events

The actual shoot is just one part of this giant moving target. What happens next is all part of the experience and the sales process. If you leave clients with a bad taste in their mouths, they won't spend. They'll be too busy being pissed off about the poor service.

That being said, what's next? Don't overcomplicate the process, but don't oversimplify it either. These steps are critical.

Step 1: Scheduling the Shoot

The experience begins with the initial contact of the client. Truth is, the sales process begins as well. Are you asking the client what they're looking for? Why are they coming to you and what's their goal for the shoot? These are all questions that get the clients thinking about artwork for their home versus looking for snapshots and a bunch of wallets. At this point, the client is the parent—and by that, I mean mom. Ninety-nine percent of the time we are dealing with moms. The fact that they are calling means you have already won over your other client—the senior.

Step 2: The Shoot

Timing—as soon as possible. On the shoot, you should be talking to the client again about their goals and reinforcing the conversation that occurred on the phone during the initial booking. This ensures everyone is in sync when they get to see their final images.

Once the shoot is over, everyone will naturally want to know what's next because they are super-excited. And you should be able to tell them what to expect. They should receive an email within 24 hours of their shoot scheduling them to come in and preview their images.

Step 3: Preview

Timing—two weeks. Yes, two weeks! Procrastination here will kill your sale. Life gets in the way. More important things creep in and people lose interest. Strike while the iron is hot and the seniors are excited to see their pictures. This is where I see most studios fail. Yes, it takes more time to have them come in and walk them through the process, but we've beaten this like a dead horse: Get them in! When you send the email to schedule their preview, you must also include a list of specials and discounts you'll be offering that night. They don't have to purchase anything, but if they want to take advantage of, let's say a 35–40 percent discount, they must be able to see those specials before they get to your studio.

Step 4: Final Delivery

Timing—two weeks after preview. This depends on what was ordered. Obviously, if they're ordering albums or other specialty products this will take longer than two weeks, but that should without a doubt be communicated to the seniors and their families so they understand what timing looks like. Everything else should be delivered as quickly as possible. Again, people are excited and they've spent a lot of money with you—don't make them wait. In fact, develop a delivery schedule that you can give your seniors for their records. This again keeps everyone on the same page and avoids frustration.

The Sales Session

Let's talk about the sales session for a moment. What should happen here? How do you run it? These are all great questions and I'll share our process with you. However, I want you to find your own process. Find what works for you and your clients. Use what we're doing as a template and for guidance. I don't think my way is the only way. I do think that having a sales session is the only way. I'm a huge believer in it, mostly because I've tried it both ways. I've tried posting online and praying for the sales to roll in only to be disappointed with no order—or one that is under $100. Then I moved to the sales process we have today to find much more predictability and higher sales averages.

So, what does the sales process look like? Let's break it down in a bulleted format. Here are the things you need to consider beyond what we've already discussed:

▸ **Samples.** You have to show it to sell it. Everything you offer—canvas, metal, acrylic, etc.—has to be shown to the client. Now by "everything," I don't mean every single size. But you definitely want to have the various products in the larger sizes you're trying to sell.

▸ **Drinks.** Make this an experience. For seniors, we have soda, snacks, and alcohol for the parents.

▸ **Presentation.** We use a large flat-screen TV. The TV has been calibrated to our computers to ensure we can get the look as close to the print as possible. We then use Lightroom to showcase the images and narrow down their selection. Take them through all their images and the selection of their favorite images. This will vary depending on your workflow and how many images you shoot. The goal should be to get them to select as many images as possible. We tell our clients, "This has nothing to do with what you're ordering; it allows us to look at what you like versus what you don't like."

▸ **Package selection.** Even though you sent this information in your email, once you walk them through all the images and they narrow them down, it's time to walk them through what you sent them in email. While doing this, you must show them each product—hand it to them, show it to them on a wall, let them see and feel the quality of your products. Doing so will help in the sales process. Once this phase is done, you merely ask for the business. We close with this: "Tell us where you want to be and we'll help you start picking pictures."

It's that simple! Don't overcomplicate it. Don't allow awkward silence to creep in. Operate under this simple assumption: They came to you to buy pictures, and as luck would have it, you sell pictures. Let the process happen naturally. Your job is to guide them and make recommendations on what would like good in their home. Do that, and you'll find that selling isn't really selling at all. Instead, it's a value-added service we offer our seniors.

Final Delivery

Once the senior has selected and ordered their images, the sales process isn't complete. It's not complete until the final delivery has been made. Therefore, giving some thought to what the delivery process and timeline looks like will go a long way toward your overall success and future referrals. Sure, they've already purchased something from you, but you want them again in the future, don't you? You want their friends' senior portraits, right? You want their wedding a few years from now, right? So, from that perspective, you're kind of still selling in a sense. It's just a different kind of selling. You're selling and confirming the value of you.

Final delivery should be an experience in and of itself. Don't just deliver the images in a plastic bag or loose in a black box. Give it thought. Check out these pictures of how we package and deliver our products. Thought went into this. We put meticulous care into this process to ensure we're giving our clients what they're paying for. We want everyone in the family to see this and experience this firsthand. In fact, it's not uncommon for mom to stop by the studio to pick things up, open them right then and there because she can't contain herself, and then ask us to rewrap it for her so her husband and child can have the same experience. I love it! That's awesome and tells us we're more than just a company that shoots and delivers images on a DVD. That's not what people want, regardless of what some people might have you believe. They want an end-to-end experience.

Next Steps ▶▶▶

I hope all this makes sense and has been a good argument to get you moving on to a sales process versus just posting images online. I promise you, selling doesn't have to be hard or dirty. We've built our business on a strong foundation that keeps clients coming back and referring new clients. That wouldn't have happened if we'd used an overly aggressive sales process.

So what's next for you?

▶ If you're not currently selling, start! Try something new. Give it a shot. What's the worst that could happen? You make more money? The first time I did a sale in my home versus online it was a $1400 sale. I did nothing different but bring them in.

▶ If you're an established studio, take a good look at your process and ask how it could be better. Don't give me that "It's working the way it is" nonsense. It can always be better. If I can continue to tweak my process, so can you. Commit to perfecting the process.

▶ Put a plan together to figure out when the right time would be to move to a dedicated space. The answer is different for everyone, but you're armed with the things to consider before making that move.

▶ Start building your samples now. You have to show it to sell it.

▶ Improve your turnaround time.

▶ Become the trusted adviser. Help your clients figure out what they need.

Stop making excuses. This approach works. It will change your life and your business.

ten

The Business Plan

NOW THAT YOU know you want to be in business, it's time to put the actual plan together so that you can start implementing the various tasks that lie ahead. Starting a business without a plan is like walking into a dark room and aimlessly looking for a light switch. You might find it in 10 seconds or you might never find it. Most, unfortunately, will never find that switch.

Your business plan is your blueprint and will ensure you're on the right path to success.

In my previous book, *The Photographer's MBA*, we outlined a generic business plan. Now, we'll put one together that focuses on the business of senior photography. This will give you a head start on your business. Once again, use it as a blueprint for your own business. You don't have to use everything I write verbatim; tweak it for your own market and business.

It Doesn't Have to Be Painful

Don't overcomplicate things. It doesn't have to be hard to put this plan together. Business plans come in all shapes and sizes. They can be as simple as bullets on a whiteboard or as complex as a Fortune 500 company diving into a new venture. Whatever you decide, it's more important that you document your goals and vision than wander around aimlessly.

And for the record, we've done both in our studio. Some years, we're very detailed in our plan, and in other years we use a whiteboard to track objectives.

Now you might be thinking to yourself, "Wait, Sal, are you saying I have to do this every year?" The short answer is a resounding yes!

Although you don't want to reinvent your business every year, I think there's a certain part of your plan that should be part of a living document. This ensures your company remains nimble and relevant. I've watched companies in all industries die a painful death because they refused to change direction—a direction, I will point out, that was being driven by a faulty and outdated business plan.

You don't have to look far to see the graveyard of companies in our own industry that refused to change direction. Kodak is one of the first companies that comes to mind. They blatantly and (I would argue) irresponsibly ignored the digital revolution that was coming and kept following an obsolete business plan. By the time they started to react, it was too late. Smaller and nimbler companies stole massive amounts of market share from them or established themselves as leaders in their respective segments. This forced the onetime industry leader to play catch-up for the first time in their history. And the rest is, well, history.

The question is, what can you do to ensure this doesn't happen to you or your business? There are a lot of lessons to be learned from the world of corporate America. Don't ever underestimate these scenarios or think that it can't happen to you. It has happened to small businesses all over the world and it can happen to you!

As a studio, we want to make sure we're always leaders in our industry, both on the consumer side and on the educational side. In order for that to happen, we have to consistently reevaluate our business plan and ensure we're heading down the right path. We treat our business plan as a living document that can and should evolve over time.

Let's start with some basic definitions to establish key terms.

Key Terms and Definitions

Let's quickly tackle our key business terms: the business plan, the mission statement, and the vision statement.

Business Plan

A business plan is a formal set of business goals, data to support how they're attainable, and the plan for reaching those goals. It can also contain information about the team working toward achieving those goals. The plan should also identify the target demographic, branding, and needed financing.

The business plan can be targeted toward an internal audience or an external audience. If you're looking to raise capital to jump-start your business, you'll need to put together a plan targeting an external audience. This plan should highlight the team and their qualifications that will make executing this plan possible. In addition, you'll have to identify your target market, how you'll market to them, change perceptions, develop an IT plan, and so forth. Remember, these are people investing in your business, so they're going to want to see all the information needed to make a decision.

For an internal audience—that's you, by the way—you'll need a similar plan, but you won't have to establish your qualifications since you shouldn't be trying to impress yourself. The goal here is to ensure you understand your product/service and your plan for achieving your goals and objectives.

Mission Statement

A *mission statement* is a statement of the fundamental purpose of your business. Your mission statement should guide the actions of your studio, spell out its overall goal, provide a path, and guide decision making. It provides the structure for your studio to guide and formulate its strategies moving forward.

A sample mission statement might include these goals:

▸ Raise the bar for high school senior photography.

▸ Create value for our clients.

▸ Deliver high-quality products and services.

▸ Provide our clients with imagery that will stand test of time.

Vision Statement

A vision statement outlines what your studio wants to be. It can be emotive in nature and based on ideals. It's a long-term view and serves as a source of inspiration for your studio.

For example, your vision statement could include the following:

▸ **Service.** Provide customer service to our clients that's second to none.

▸ **Creativity.** Offer an inspirational level of creativity to inspire our staff and clients alike.

▸ **Innovation.** Never stop learning, growing, or innovating. It's the lifeblood of the organization.

Critical Success Factors

Certain factors or elements are vital to ensure that your strategy is successful. You must decide what your critical success factors are in order to execute your business plan.

For example:

In order for us to achieve our goals of running a successful senior photography studio, we need to ensure that we have access to quality education and training. In addition, we must reinvest in our people and process to ensure they can deliver the level of service needed to provide a competitive advantage in our market. And finally, we must continuously seek out high-quality products for our clients to solidify our ability to deliver value.

Strategic Planning

You must define your strategy, or direction, and your decision-making process. To determine the direction of your studio, you must understand its current position and the possible opportunities available to you. Typically, planning addresses these questions. What do we do? Who do we do it for? And what's our competitive advantage?

Putting It into Practice

Now that you have an overview of some high-level definitions, let's try to put some of these concepts into practice with some real-world exercises and examples. The goal here is to show you how to put some of these concepts into motion with your own business. So, get out a pen and pad of paper and start working this into your own business. Don't take these exercises lightly. Even if you've been in business for the last 20 years, you can always fine-tune your business. This reinvention should become a part of the culture of your organization.

Your Mission Statement

Your mission statement should highlight the fundamental purpose of your business. So, I want you to think about the fact that you're reading this book because you either are into senior photography or want to start. You have to begin focusing your effort.

When I started out, I was doing a little bit of everything and I was miserable! I realized quickly that there was no way I could be everything to everyone. I wanted to do what made me happy, and seniors and weddings are my passion. If you look at my website, you'll see nothing but seniors and weddings. Do we shoot other types of photography? Of course we do. However, we do so on a limited basis. My business is built on these two types of photography and everything we do has to be tied to that.

Next, I want you to think about why your business will exist. I probably just blew your mind with this. I can hear you now: "What do you mean, 'why do we exist'? We exist to make money." If that's your initial answer or initial thought you might want to step away from this book for a few moments.

Sure, on a basic level, all businesses have to turn a profit of some sort. The business has to be able to pay its bills, grow, and advertise. However, when it comes to your mission statement, you need a bigger motivator than just money or you'll fail! And you'll fail because you and your business are being driven, at the core, by the wrong motivator—money.

For us, on the educational side, my business behindtheshutter.com exists to raise the bar of professional photography around the world and help

photographers reach their true potential. Notice that there's nothing about money. If you run the other aspects of your business correctly, money will ultimately find you and be the reward of a well-executed business plan.

Let's look at Coca-Cola, one of the world's most recognizable brands, for some inspiration here. Their mission is to refresh the world, to inspire moments of happiness, to create value and make a difference.

See anything in there about money? Their mission statement serves as their foundation for everything the company does.

How about this for a potential mission statement? "At XYZ Studio, our mission is to raise the bar for high school senior photography in our local market and become a destination for our clients by creating imagery that will stand the test of time. In addition, we want to provide value to our clients by creating and delivering superior customer service and high-quality products."

This is something I put together quickly. You should spend time thinking about your ultimate goals. A mission statement like this will dictate the strategy of your company and serve as a blueprint for you as you grow in the future.

Your Vision Statement

While your mission will dictate the purpose of your company, your vision is going to dictate the actions needed to become the company you want to be. Think of it as a framework.

Don't get confused by this concept. You might initially look at this and think, "What's the difference between a mission and vision? They sound the same."

Think of the vision as a high-level set of tenets that will have to be adhered to in order to accomplish your mission. You don't want to get too granular here—for example, "must send out direct mail during the month of June." That's way too granular and may change over time. You want your vision to focus on a high level so that as your business evolves and the landscape changes, you can adhere to your vision yet still change your tactics. This allows your studio to be nimble when dealing with the never-ending changes in our industry.

Let's go back to Coca-Cola for some real-world examples. Their vision statement reads as follows:

OUR VISION

Our vision serves as the framework for our roadmap and guides every aspect of our business by describing what we need to accomplish in order to continue achieving sustainable, quality growth.

People: Be a great place to work where people are inspired to be the best they can be.

Portfolio: Bring to the world a portfolio of quality beverage brands that anticipates and satisfies people's desires and needs.

Partners: Nurture a winning network of customers and suppliers, and together we'll create mutual, enduring value.

Planet: Be a responsible citizen that makes a difference by helping build and support sustainable communities.

Profit: Maximize long-term return to shareowners while being mindful of our overall responsibilities.

Productivity: Be a highly effective, lean, and fast-moving organization.

One thing that should immediately jump out at you is the fact that their bullet points are generic and high level. They're trying to create a framework to guide the organization in achieving its goals and objectives. And with Coca-Cola's history, I'd say they are doing something right.

So, let's try to apply this vision to our world:

▸ **People.** Be a great place to work where people are inspired to reach their creative potential.

▸ **Partners.** Nurture a network of professional relationships, creating enduring value for our clients.

▸ **Productivity.** Be a highly effective, lean, and fast-moving team ready to adapt to a quickly changing marketplace.

▸ **Customers.** Value the relationship of our customers, making their experience a positive and memorable one.

Again, this is something I spent a little time thinking about and coming up with some real tenets that can help drive the business in the right direction. In addition, think about this: As your business grows and you add new staff, additional shooters, and so forth, how will you communicate with them to ensure they share the same vision as you do for your company? This is how: Document it and make it real for everyone, including your clients, to see.

I highly recommend placing your vision and mission statements on your website for the world to read. Today, I see photographers posting what they had for breakfast on their blog—which no one cares about, by the way—but somehow we're shy about posting the core beliefs of our company? Think about it. This is what clients care about when they're selecting a company to document one of the most cherished moments in their lives.

The Business Plan

Okay, so we have our vision and mission statements together. Now we have to start drilling into the business plan. Remember, this doesn't have to be a 30-page document. It can be as simple or as complex as you like. And since you're more than likely not looking for venture capital for your business, we're going to focus on an internal document versus an external one, say for a bank. This becomes your living document that should drive your 12-month, 2-year, and 5-year goals. And I strongly emphasize that this is a *living document* because my 5-year plan today looks nothing like it did when I first started my business. And that's to be expected. It's a sign that our business is dynamic and is responsive to changing market conditions.

First let's identify the key elements of the business plan we'll be putting together:

- ▸ Executive summary
- ▸ Market analysis
- ▸ Company description
- ▸ Organization and management

- ▸ Marketing and sales strategies
- ▸ Service or product line
- ▸ Financial projections

This is a great starting point, and though some of these might seem complicated, I promise you once we get through this, you'll see how priceless this document will be for your business, especially if you're just starting out. I do a lot of consulting for businesses, and the number of businesses that haven't taken this step dumbfounds me. This document is vital to the success of your venture.

So let's start with the executive summary.

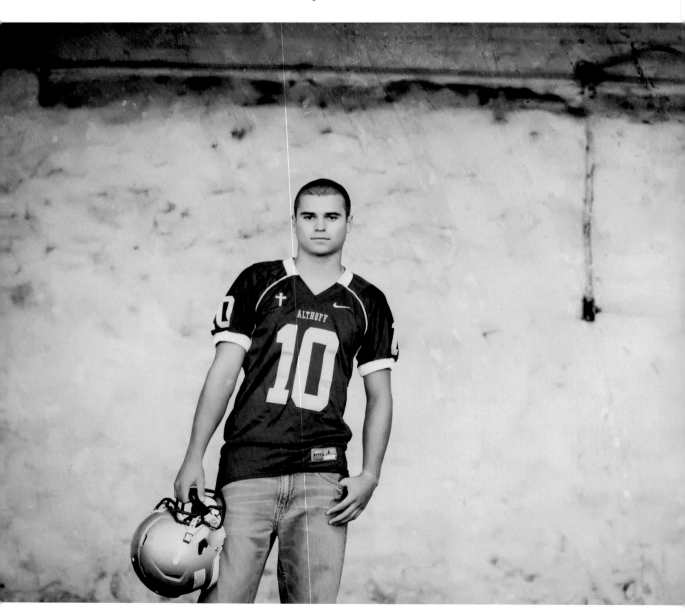

Executive Summary

The executive summary is widely considered to be the most important part of your business plan. Think of it as the who, what, when, where, and why of your business. It's the one place you can look to define most aspects of your business.

The executive summary should highlight the overall strengths of your plan, and it's usually the last piece written. However, it's first in your final document.

If you're an established business, include the following information:

▸ **The mission statement.** This statement should already be completed.

▸ **Company information.** Include a short statement that covers when the business was formed, the names of the founders and their roles, the number of employees, location information, and so on. For example: "Salvatore Cincotta Photography was founded in 2007 by Taylor Cincotta and Sal Cincotta. While Taylor is in charge of sales and customer interaction, Sal owns marketing and is the senior photographer. Today, Salvatore Cincotta Photography is located in O'Fallon, IL, and has 5 employees."

▸ **Growth highlights.** Include information about the company, when it was founded, year-over-year growth using graphs, your market share, and so on. For example: "Since 2007, Salvatore Cincotta Photography has claimed significant market share in the St. Louis Metro area with 400%+ growth in the wedding and senior markets."

▸ **Your products or services.** Describe the products or services you provide and who you're targeting with them. For example: "The company focuses on High School Senior Portraits and Weddings. By providing superior service and high-quality products, Salvatore Cincotta Photography has established itself as a market leader."

▸ **Summary of future plans.** Where are you going with the business? What are the ultimate goals over the next 12 months? For example: "Within the next 12 months, the business is planning for 50% growth in the senior market. By using targeted social media and grass roots campaigns, we see demand rising and increasing profits by 30%."

If you're a new business, you might not have some of the financial information as of yet. And that's okay. Use forecasted numbers based on market data. It's a best guess and should be based on a somewhat realistic assessment of your market, but it serves as a checkpoint for your business moving forward.

Market Analysis

Your market analysis should include information about the industry and market research. For example, if you're going to be a senior photographer in Los Angeles, what does that market look like? How many seniors per year are there in your defined market? What is the average spend on senior photography in your market?

What's included:

▸ **Industry description and outlook.** Describe your industry, including the current size and any historical and projected growth numbers.

▸ **Information about your target market.** Here you'll have to do some thinking about the target you're going after. For seniors, every senior graduating isn't your defined target. That's completely unmanageable. Who is your target? That can be defined by demographic data like religion, income level, or geography. Our studio focuses on mid- to high-end families with a senior in the home—people willing to spend $1,000–3,000 on portraits. If we were to drop that number to $500, we'd place our studio within an entirely different competitive range and within a completely different client base. Once you narrow down your demographic, you need to determine the size of your target market. What are some of the behavior characteristics, such as average spend, of that market? What are the demographics (income level, geography) of that target? Some of this data is easier to find than others. There are two places we go to for our senior data—American Student List (www.asl-marketing.com) and InfoUSA (www.infousa.com).

▸ **Competitive analysis.** Identify your competition in the market segment you're going after. What market share do they have? What are their strengths and weaknesses? What barriers to entry are there to getting started in this segment?

- **Company description.** This section provides a high-level overview of your business and the various elements of your business. Define the goals of your business and the unique value proposition you're offering the targeted market segment. Your company description should describe the nature of your business and the needs you're trying to satisfy, explain how your products or services meet those needs, list the specific consumers and target market your business will serve, and explain and list your competitive advantages.

Organization and Management

Don't let this part of the business plan overwhelm you. If you're like most small studios, you're the owner, manager, and photographer. I get it, we all wear different hats. And there's nothing wrong with that. However, if you're working with your spouse or friend, this becomes a great place to highlight clear lines of roles and responsibilities so you don't kill each other during stressful periods.

In this section, include the organizational structure and details about the ownership of the company. Basically, cover who does what for the business:

- **Organizational structure.** Create an organizational chart for your business highlighting reporting lines and titles.

- **Ownership information.** Define the legal structure of your business along with the ownership information. Include such information as names of the owners, percentage ownership, and involvement in the company (silent partner or managing partner).

- **Management profile.** This might seem like a pointless exercise, but it truly is a great way to look at your business and key roles in a way that will quickly show you holes in your structure, holes that could ultimately lead to the failure of your business. As a photographer, you'll find it's an all-too-often perceived notion that all you need is a camera and you're ready to go. Sounds great, right? Now you've got the camera and you've got some images. Okay. Who's in charge of marketing? Post-production? Sales? This is where most businesses fail. They don't have the required people or partners to fill the gaps in their management team.

It's okay if you don't have all these skills. Very few people do. So, you either hire these people or bring in partners to assist. But you have to make yourself aware of the problem before you can fix it.

Something else to consider—working with your spouse. This can be one of the most rewarding and most challenging, relationships of your life. I know it is for me. On one hand, I'm working with my best friend and we're building something together. On the other hand, I'm working with my wife, who doesn't like to be told what to do. If you work with your significant other, I know you feel my pain. Here's what I recommend when it comes to ownership of tasks. Create clear and distinct lines of ownership between you and your partner. This allows for what I call "no fly zones." Taylor has her tasks that she owns and while, as a partner in this business, I get a vote, she ultimately owns the task. And the same goes for me in reverse. So, this has helped us tremendously toward achieving the goal of not killing each other as we build our business together.

Marketing and Sales Strategies

Marketing in its simplest form is defined as the activities involved in the transfer of goods from the producer to the consumer. This includes advertising and selling. It's all part of your marketing strategy. A lot of people think of advertising as a separate discipline; however, it's part of your marketing strategy—typically the most expensive part.

There's no right or wrong way to approach your marketing strategy. It should be a living process and document that's continuously evaluated and nurtured based on market demands and changes. What worked in the 1990s might not work today. Our philosophy is simple—we'll typically try anything once, but if it doesn't work, we move on.

Your overall marketing strategy should include

▸ **Market penetration strategy.** How are you going to get into the market? There are a lot of photographers competing for the same business. What makes you different? Are there relationships that you need to have in order to be successful? Who and how will you foster these relationships? As a senior photographer, you'll need to get into the schools

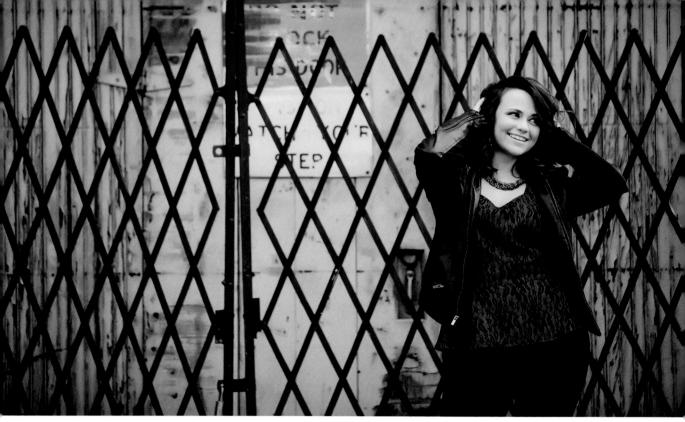

on the preferred vendor list. How will you do this? Who do you need to contact and work with at the various schools?

▸ **Growth strategy.** What's your plan to grow the business? For example, if you shot 10 seniors in 2013, what's your plan to get to 50 seniors for 2014? It's not going to happen by accident. And I sure hope you're not just using Facebook and referrals to make it happen. Don't get me wrong; those approaches are helpful, but you have to have a solid plan in place.

▸ **Communication strategy.** How are you going to reach your potential customers? You need a multiprong approach here—social media, brochures, flyers, vendor partnerships, advertising, press releases, and so on.

Your overall sales strategy should include a sales force strategy and sales activities. Let's take each in turn.

Regarding your sales force strategy, how will you run the sales process for your business? Will you sell online, in-studio, in the client's home? These are big decisions for your company and will ultimately impact your revenue streams. Sales in our industry typically refers to two different parts of the process. In the first part, you're selling clients on working with your studio. Maybe you're selling the benefits of booking with the studio. Or it could be a portrait session, where you're selling clients on booking a session with your studio. This part of the process can happen either on the phone or in the studio or meeting space.

The second part is focusing on the post-event sale. Now they've had their session and it's time to purchase pictures. What's the strategy here? Will you handle this online, in-studio, or in the client's home?

I like to focus on the initial booking. To that point, who will do it? What will the process be? Will it be you as the principal or will you hire someone? If you hire a full-time person, how will they be trained? These are things that you must think about ahead of time.

Regarding sales activities, here's where you need to get a little more granular on the sales process. What does the sales process look like and execute like? For example, let's break it down by task. For my seniors, here's a typical workflow:

▸ Call or email comes in requesting pricing information.

▸ Template response email goes out with general information driving the potential client to a phone call where we can walk them through the process.

▸ Once on the phone with the client, we explain the process, what to expect, ask if any of their friends or family have worked with the studio, and answer any questions they have. Then we try to book the session.

▸ Either the client books or we move on to the next opportunity. We give them as much information as we can and try to book them on the phone. We don't have them come to the studio for a tour; this is a senior session, not a wedding. We don't have time to spend with every client kicking tires on where to book. And ultimately, does it matter what my studio looks like? To me, what matters are the images we produce.

You can see that we have clear activities that take place for each step in the process. This process has been refined over the last four years. It's simple to execute and not overly sales-y. So, there's no right or wrong answer here. Just take the time to map out your strategy and adjust if it isn't working.

Service or Product Line

Next you want to describe exactly what you're selling. As simple as this might seem with an answer like "photography," you must drill down and get specific with what you're selling and the benefits to potential customers.

Provide a description of your product or service. Spell out the specific benefits of your product or service from your customer's perspective—not yours! If there's no discernible difference to the client between your product or service and that of your competition, then it doesn't matter what you think. It's the client's dollars that dictate success or failure, not how we as artists feel about our work.

For example, for our studio's senior photography business, I offer this description of our service: "We offer a once-in-a-lifetime model experience for our high school seniors, complete with hair and makeup and a photography style that screams individuality for our clients. Clients looking for the ultimate in senior portraiture will be treated to larger-than-life imagery that will be shared and enjoyed for years to come with our lifetime warranty and archival products."

Now, I could expand on this even more if I chose to. That's up to you, but I would say, and I hope you agree, that I'm very aware of the value proposition we offer our high school senior clients.

Financial Projections

Once you've taken a good look at the market and developed your goals and objectives, it's time to start thinking about financials. This section should show your historical numbers and include future projections based on the business landscape. If you're just starting out, obviously you won't have much, if any, historical data for your business, and that's okay.

I'm going to get away from the typical or more traditional way of completing this section and describe my way of looking at the financials. This is how we started our own company and how I work with other photographers we're consulting with.

How much money do you want to gross? Basically, how much do you want to make? Sounds crazy, right? However, I firmly believe that we all have this amazing opportunity in front of us and we're limited by nothing but our own fears. We create the box of limitation. And right now, I want you to think outside that box.

Let's start with a reasonable number. Since the average photographer grosses about $45,000–$50,000 per year according to most industry numbers, let's start with $150,000.

Great. Now, let's break that out.

Our studio can do 25 weddings at a $4,000 average and 50 portrait sessions at a $1,000 average. And it's that simple! For me, this is an achievable financial projection and now should be part of our new business plan.

Next, how do we get there? That will be defined in our marketing plan, but these are real numbers that I think are very attainable. The average wedding photographer can get around $3000 contracted average. That leaves you with just $1000 more to get per wedding. Can you get a $500 engagement sale and a $500 spend after the wedding on things like an album upgrade, framed prints, or canvas? I think that's a very attainable number. This will be tied to your sales strategy to make this happen.

Let's talk seniors. Your session fee should be between $100–$300 depending on where you're at in the market. Any less and you're going after the wrong level of client. Any higher, and you run the risk of being so elite in the market that you alienate 90 percent of it. For this exercise, let's focus on $200. Perfect. You've already hit 20 percent of your goal of $1000 average. Remember, this is an average; some will spend more and others less. And that's fine. Now, can you shoot enough great shots to get the family to spend an additional $800 after the event is over? That's on you. I say *yes!* Think back to the packaging and pricing chapter. If we know $800 is the nut we're chasing, then guess what the price point of that middle package should be? You guessed it—roughly $800. Could be $999. But if your middle package

is $400, you will *never* hit that average you're listing out in your business plan. Did the lightbulb go off? I hope so.

You might be wondering why I even threw weddings in here. For us, weddings are part of our business plan. These seniors will someday get married—and I'm not talking 20 years from now, I'm talking 5–8 years from now. We want that business. In addition, weddings allow me to forecast the year ahead. I can look at my booked contracts and see what next year looks like based on contracted weddings. I can't do that with portraits. So, it's just something to consider when growing your business.

Everything we do in our sales and marketing plan has to be tied to making these numbers happen.

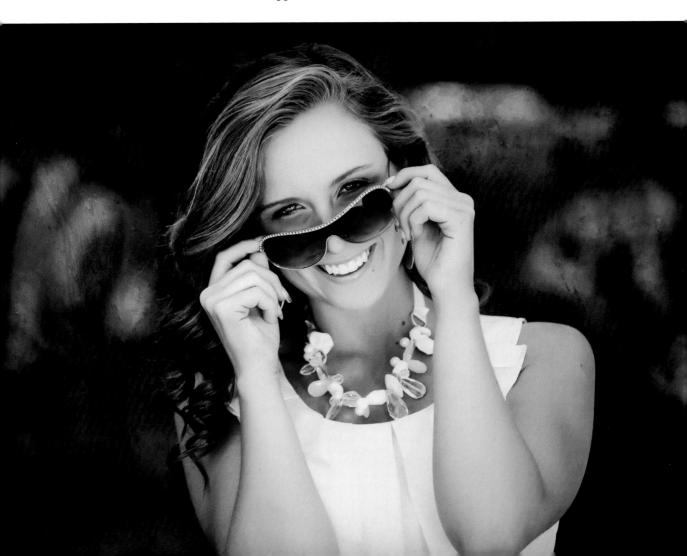

eleven

Get Started Now

S O, YOU'VE MADE it through this entire book and the question must be asked: What's next? Now you have to make a decision: Is this something you want to do? Is this something you're going to make a million excuses about why you can't do it, or will it be something you go at full force and lay it all out on the line with only yourself to hold accountable?

This is the choice that lies ahead. I've gotten you to this point. I've given you the information you need to start this venture, but only you can take that next step. Look at this chapter as a short motivational chapter that you come back to from time to time to check in and make sure you're at least heading in the right direction.

All of us are at different levels in our business and with our technical skill set. In addition, as we begin to implement these new ideas we'll continue to grow. As we grow, we'll process information differently. My point is this: Use this book as a reference guide, come back to it often, and see how the information changes based on how your perspective has changed.

Here, I want to go through a sort of step by step of what should happen next or at least as a sequence of events. Some of these steps can, in fact, happen in parallel, and as I said already, this should be a guide of sorts. For more information, go back and drill into the earlier chapters.

Step 1: The Business Plan

I know this isn't the sexy stuff. You want to get out there and shoot and do all the fun stuff and buy all the cool new toys, but that's not how you create and run a successful business.

You have to focus on this part first. You have to come to the realization that while we're photographers, we must be businesspeople and entrepreneurs first.

If you don't accept this now, I fear you'll soon end up like all the others, scraping to get by or the eternal hobbyist. Either way is okay, I suppose. It's up to you. This is why the business plan is so important and why you should invest the time here. The business plan will lay out the roadmap for your business and hold you accountable.

And please don't misinterpret what I'm suggesting here. Success is for you to define. Success isn't necessarily running a million-dollar studio. The business plan helps you here. It helps you to define what success means for you and your business.

Invest here and lay out your path to success. I promise you, whatever your goals and aspirations are, this is a must-do task.

Step 2: Define Your Market

Your first thought should be, "Isn't this part of the business plan?" And the answer is yes, but you have to sit and start your business plan first.

I've watched photographer after photographer start their plan without ever looking at what the local market demographics look like. That's pure insanity to me. The funny thing is, it's not only photographers who do this; it's business owners the world over. They all suffer from the same disease: the build-it-and-they-will-come disease.

Sadly, business doesn't work this way. I guess you could be blessed with dumb luck in your life, but why chance it? Do the research. Know what you're getting into up front. Don't assume anything.

In fact, what do you do if you find out there's no market? That's the bigger question, isn't it? Many of you have contacted me over the years telling me, "There's no market where I live." You are in a small town, too far from a city, etc. *Move!* Yes, *move!* We've all heard the three tenets, haven't we? "Location, location, location!" Your business is not above this. You have to go where the money is. If this is your life, your passion, your dream—then damn it, set yourself up for success.

Our studio is in a small town outside of the St. Louis metropolitan area. We're about 25–35 minutes from downtown. I don't think we're in a big area, but we're not in a small area either. If we weren't finding the right demographic, I can honestly tell you we would move.

Step 3: Pricing

"Come on, Sal! Are we ever going to do the fun stuff like shooting and playing with all the new lights and memory cards?" Yes. Soon, grasshopper. Very soon.

What are you going to do when the phone starts ringing and people want to know pricing? Scramble? Guess? Or better yet, put out older pricing that will have horrible profit margins and start attracting more of the wrong client?

That can't happen! You must get your pricing in order. Read the chapter on pricing ten times if you have to. Your pricing has to be ready to roll out when you start putting your business plan together. This is paramount to the success of your business.

Remember, your pricing is a living document. It can and will change over time. In the beginning, our studio was raising pricing often based on what we were seeing from a demand perspective. Don't lock your pricing in for months and years at a time. Keep a close eye on trends, spending habits, and new products that have higher margins for you, and don't be afraid to experiment with your pricing. You'll be surprised by what people are willing to spend. Don't ever forget: People have money for what they want to have money for.

Step 4: Web Presence

This is your storefront. This is the place where you'll be sending people the minute your marketing gets out there. What will they see? A Facebook page? A website that looks like my grandmother made it? Let me get this right; you want to go after high school seniors—the most finicky demographic out there—and you want to wow them with your homemade lame website? Good luck with that.

If you're serious about seniors, you have to get this going as soon as possible. Can you do it yourself? I suppose. I know I tried. The funny thing is, I used to do it for a living and I failed. I failed in the sense of not giving it the time it deserved. I had all the best intentions, but the reality is that my time is better spent on other aspects of my business. What happened? Just like every one of us is guilty of, bigger priorities won out and my website was constantly put on the back burner.

The minute I outsourced this, it was a huge weight off my chest, and strangely, it was completed within 30 days. Weird how that works.

Within this part of your giant to-do list, you need to add social media—things like a Facebook page, Twitter, and Instagram. Stop procrastinating. Most of this stuff is free. Sit down and get it done.

For those of you who think you have this taken care of, go and look at your site. I'm sure it needs to be updated. Get to it. It's not a once-and-done project. A constant pruning is needed. Think about this: Would you clean your house once and be done with it for a year? *Never*. It sounds stupid to even suggest it. So, get to it on your web presence.

Step 5: Perfect Your Craft

Play time! Get out there and start doing what you love to do. Shoot. Play. Experiment. Make mistakes. Learn. Grow.

I consider ours an established studio and we're still growing and still learning every day.

Where are you weak? That's where you need to focus. And it's the perfect question, isn't it? It doesn't matter where you are in your career; we all have areas we can improve in.

Some areas that come to mind immediately:

- General lighting
- Technique
- Posing
- Off-camera flash
- Composition

Take time to invest in your technical acumen. Doing so will go a long way in defining your style and helping you stand out in a sea of photographers. Everyone is always worried about competition in their local market. Honestly, I just don't care! Not because I'm arrogant and think we're the best. It's because 90 percent of the newbies or shoot-and-burners grabbed a camera and just started shooting. They don't truly understand this craft or business. You may be in that boat today. The difference is...you're taking that step toward perfecting your craft. And that's huge!

Understanding the value of perfecting your craft will allow you to immediately leap ahead of 80–90 percent of the photographers out there. Yes, I think it's that easy. I speak from experience. We focused and worked hard, and we immediately stood out from the crowd. So can you!

Step 6: Ambassadors

This is your mobile workforce. They and their families want to know they're aligning with a top-notch business. Think about it: You're asking them to refer their friends and family and endorse you. That's why it's so important you get the basics down first. You want to make the best first impression so people trust you and feel comfortable referring you.

Start reaching out to friends and family if this is your first foray into the seniors market. Find people who are attractive and want to be in front of the camera. They'll be the ones representing your brand. They need to have energy. They need to love their pictures. They need to be plugged into their peer group. Don't just take anyone who says they want to be an ambassador. If they don't like pictures, then they're doing it for mom, and the pictures will more than likely suck *and* they probably won't share them with their

friends. This defeats the entire purpose. The same holds true if they're shy and introverted. You need kids who are socially engaged. This is the reality of the ambassador program.

Your senior business is dependent on this grassroots approach to marketing. Don't get discouraged if at first you can't find the right kids. Time will get you there. But don't settle. Trust me. I've learned this the hard way. The wrong kid can sometimes do more harm than good for a multitude of reasons. They have a bad experience with you. They don't talk about the studio the right way. The parents are overbearing.

The first year was my toughest year with seniors. Getting the right kids was tough, but hang in there and keep doing all the other things that are important to your business and you'll find a way to connect. Every once in a while, a bad apple will sneak in and that's okay too. Try your best to weed them out during the interview—also a very important part of the process.

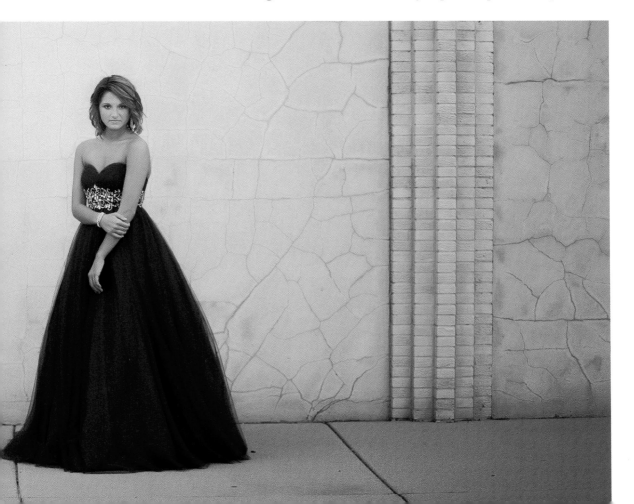

Step 7: Marketing

Now it's time to start focusing on the marketing. Things are coming together. We have pricing, ambassadors, website…. What's the marketing plan? How do we get the word out beyond our ambassadors? We need a plan! We can't just put all our eggs in one basket. Don't underestimate the importance of investing in marketing and advertising. This is a big miss at a lot of studios. They don't respect the importance of this. I'm not going to jump into every item here, but suffice to say, you need to think about this.

Not only do you need to think about this: You need to *keep thinking* about this. *All the time!* I think about marketing and advertising more than I think about photography. I have to make the phone ring to get to a point where I'm actually shooting. If I don't have clients, I can be the best photographer in the world but no one knows about me or my studio.

Keep fine-tuning your marketing efforts. Weekly, monthly, yearly. Change or refresh your branding as needed. Don't get stale. This demographic will reject you the minute you're no longer "cool." They don't want their parents' pictures. They want something bigger.

Ask yourself these questions over and over again. What do the kids want? What do they think is cool? Where are they online? What are they watching on TV? If you change your mindset you'll quickly understand the world of a teen. It's not as complicated as you might think. We were all teens once.

Step 8: The Sales Process

What's your plan? How do you plan on selling to your clients? I've made a big case for in-studio sales, but the choice is yours. What will post-production look like as it pertains to sales? How long will it take you to turn your images around? Remember, time is of the essence here. The longer you make your clients wait to see their images, the worse their experience will be, and the less likely they will be to refer you, and that will ultimately impact your sales dollars.

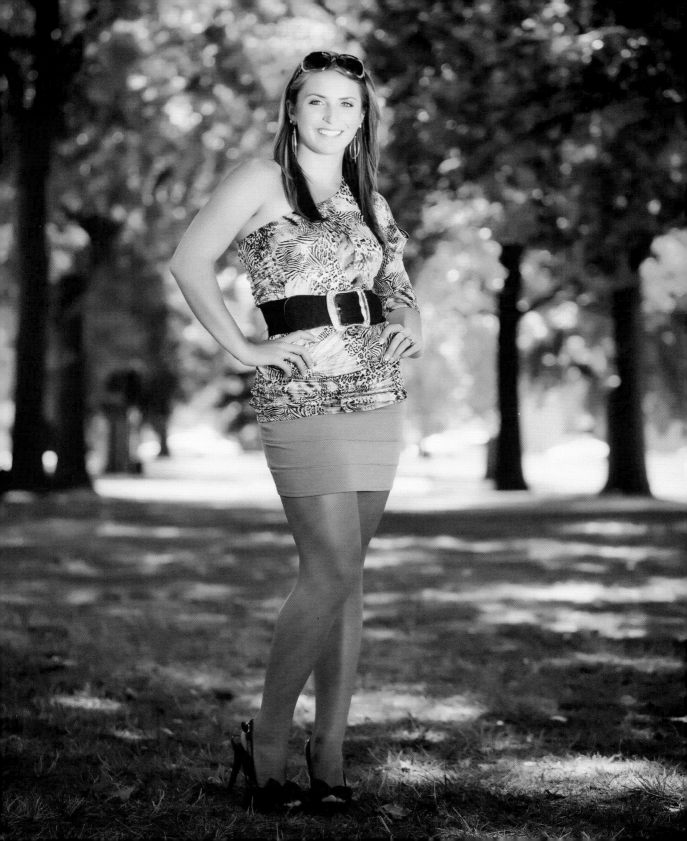

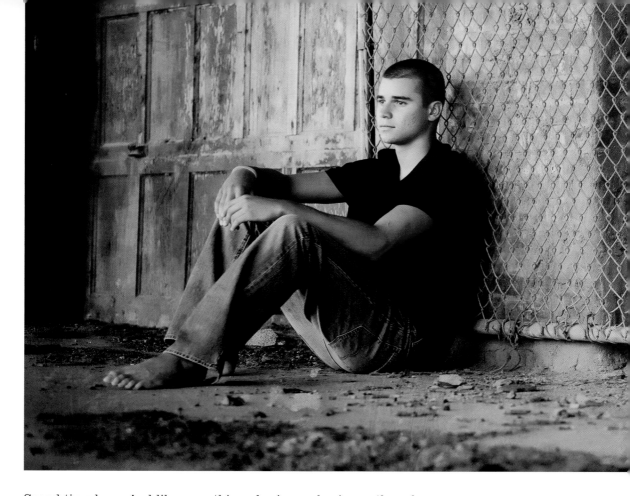

Spend time here. And like everything else in our business, the sales process is something that should be continuously refined and tweaked. We still tweak ours to this day.

You have to think of sales as the final step in this entire process. The shoot is not where it ends. Complete the entire process and give your clients an experience they'll never forget. Be the trusted adviser.

I understand—posting online is a hell of a lot easier. I never said running a successful studio would be easy. If it were easy, every studio would be successful. Posting online and the shoot-and-burn approaches *do not work!* It's an incomplete service and not a profitable business model. People want service. People will spend money if you make it easy for them. Commit to figuring out this part of your business, and be a student of sales. And remember, sales doesn't mean pushy. That's not what I'm advocating at all.

Step 9: What Are You Waiting For?

That's it. You're armed and ready to go. Get out there, stop talking, and start doing. The future is yours. I believe we can do anything we put our minds to.

Good luck!

Sal

Index

V

value, 140–146
 of creativity, 145
 of experience, 145–146
 of packaging, 144–145
 of products, 142–144
 of service, 141–142
vertical shots, 27
vision statement, 191, 194–196

W

wall portraits, 132
wallet-sized prints, 17
web galleries, 137
web presence, 213–215
websites
 age of, 163–164
 Facebook links to, 155
 header tags on, 164
 image names on, 163
 importance of, 150, 213
 regularly updating, 215
 SEO for, 159–164
 types of, 160–161
 writing copy for, 161, 163, 164
 See also social media
wedding photography, 207
white balance
 gels for modifying, 58–59
 post-production adjusting of, 77
wide-angle shots, 27
word of mouth, 16
WordPress sites, 161

X

X-factor, 145

Y

Yoast plug-in, 116

Z

zoom lenses, 27

WATCH READ CREATE

Unlimited online access to all Peachpit, Adobe Press, Apple Training, and New Riders videos and books, as well as content from other leading publishers including: O'Reilly Media, Focal Press, Sams, Que, Total Training, John Wiley & Sons, Course Technology PTR, Class on Demand, VTC, and more.

No time commitment or contract required! Sign up for one month or a year. All for $19.99 a month

SIGN UP TODAY
peachpit.com/creativeedge